Best of Flower Painting 2

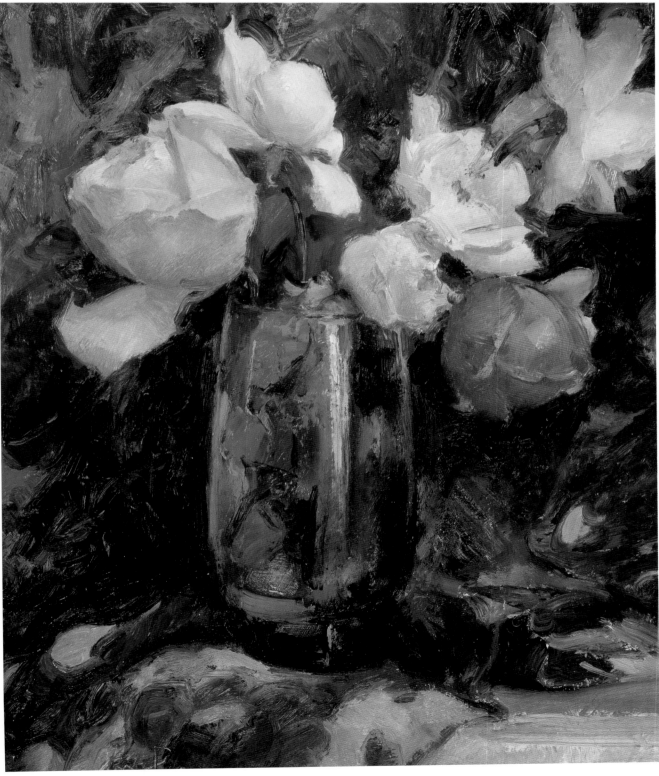

ROSE
Zhang Wen Xin, oil on board, 12" × 10" (30.5cm × 25.4cm)

Best of
Flower
Painting 2

EDITED BY RACHEL RUBIN WOLF

NORTH LIGHT BOOKS
CINCINNATI, OHIO

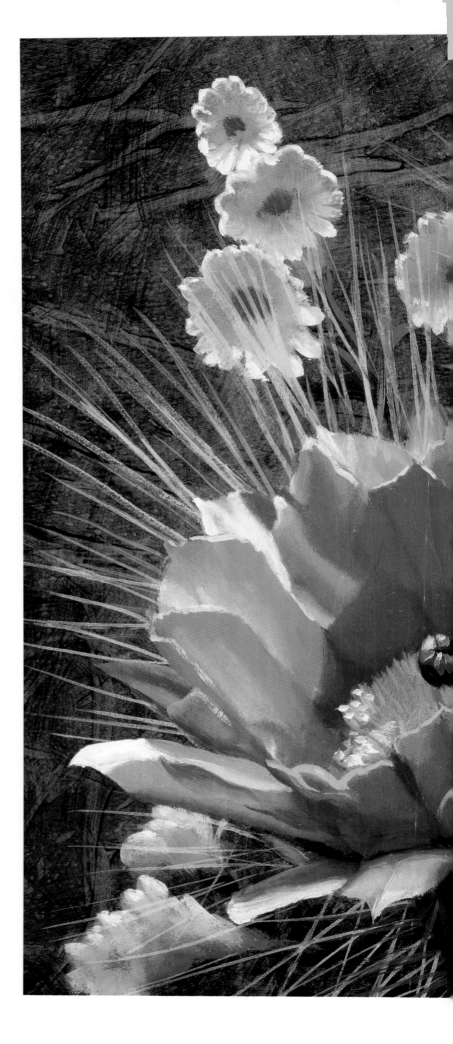

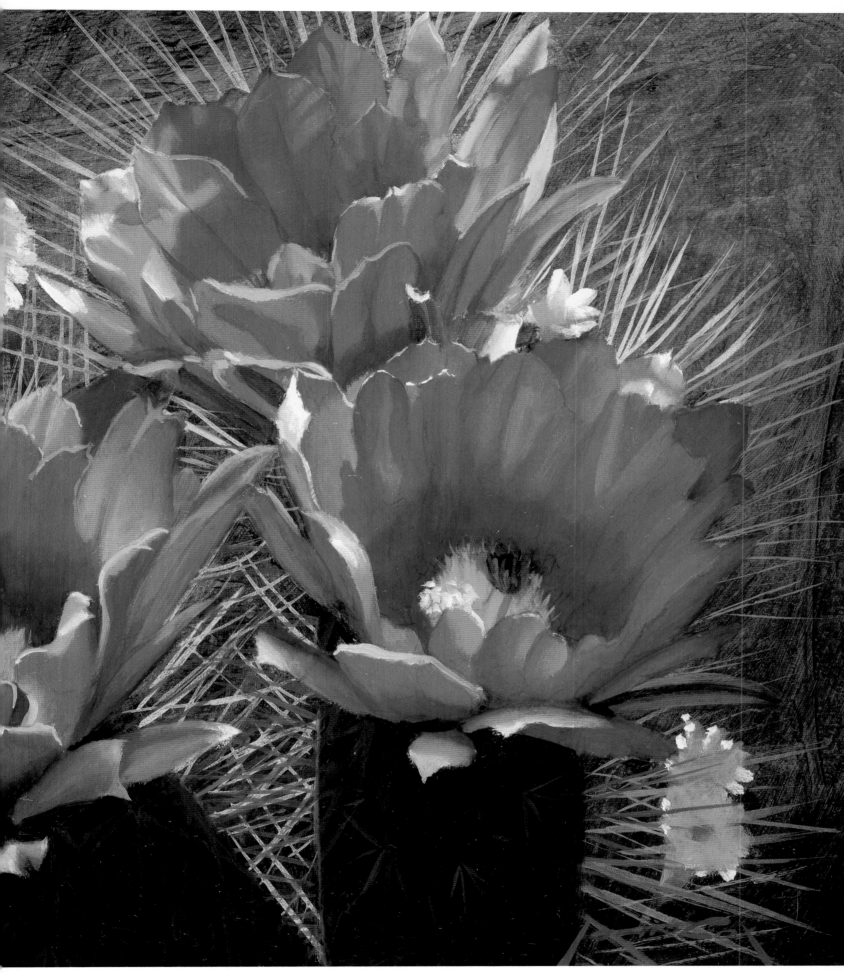

CACTUS COLOR
John Cox, oil on linen canvas
8" × 10" (20.3cm × 25.4cm)

Rachel Rubin Wolf is a freelance writer, editor and artist. She edits fine art books for North Light Books, working with many fine artists who paint in a variety of mediums and styles. Wolf is the project editor for the *Splash* series, as well as many of North Light's *Basic Techniques* series paperbacks. She is also the author of *The Acrylic Painter's Book of Styles and Techniques* (North Light) and a contributing writer for *Wildlife Art News*.

Wolf studied painting and drawing at the Philadelphia College of Art (now University of the Arts) and Kansas City Art Institute, and received her B.F.A. from Temple University in Philadelphia. She continues to paint in watercolor and oils as much as time will permit. She resides in Cincinnati, Ohio, with her husband and three children.

Best of Flower Painting 2. Copyright © 1999 by North Light Books. Printed and bound in China. All rights reserved. No part of this book may be reproduced in any form or by any electronic or mechanical means including information storage and retrieval systems without permission in writing from the publisher, except by a reviewer, who may quote brief passages in a review. Published by North Light Books, an imprint of F&W Publications, Inc., 1507 Dana Avenue, Cincinnati, Ohio 45207. (800) 289-0963. First edition.

Other fine North Light Books are available from your local bookstore, art supply store or direct from the publisher.

03 02 01 00 99 5 4 3 2 1

Library of Congress Cataloging-in-Publication Data

Best of flower painting 2 / edited by Rachel Rubin Wolf
 p. cm.
 Includes index.
 1. Flowers in art. 2. Art—Technique. I. Wolf, Rachel Rubin.
N7680.B46 1997
704.9'434—dc20 96-9433
 CIP

ISBN 0-89134-777-1 (1), ISBN 0-89134-950-2 (2)

Editor: Michael Berger
Production editor: Michelle Howry
Production coordinator: Erin Boggs
Designers: Janelle Schoonover and Angela Lennert Wilcox

The permissions on pages 138-141 constitute an extension of this copyright page.

ACKNOWLEDGMENTS

I wish to thank all of the North Light editors on the FACTeam (Fine Arts and Crafts) for your help in the initial judging process. A special thanks to content editor Michael Berger, production editor Michelle Howry and designers Janelle Schoonover and Angela Lennert Wilcox. However, as always, the biggest thanks must go to the artists who have so graciously completed all of the homework we assigned. A second and very special thank you to those of you who sent in quotations. I could sense the caring and deep feelings that these quotes elicited from you, and that made them all the more meaningful to me. I am sorry I was not able to use them all, nor even mention who sent in which ones (some quotations were sent in by more than one artist), but I am very mindful of the care and joy you took in sending them.

DEDICATION

In light of the subject of this book, flowers, I felt compelled to humbly dedicate it to the loving Designer of all things we love. Consider this:

"Suppose a case of books filled with the most refined reason and exquisite beauty were found to be produced by nature; in this event it would be absurd to doubt that their original cause was anything short of intelligence. But every common biological organism is more intricately articulated, more astoundingly put together than the most sublime literary composition…Despite all evasions, the ultimate agency of intelligence stares one in the face."

— Frederick Ferre, *Basic Modern Philosophy of Religion*

I would add that if "The heavens declare the glory of God," flowers expose a bit of His tender side, showing infinite creativity and loving attention to detail for a life that lasts but a season.

TABLE OF CONTENTS

5 *Convey Mood*

6 *Highlight a Special Subject or Background*

7 *Portray a Different Viewpoint*

9 *Create a Story or Symbolism*

8 *Stress Contrast*

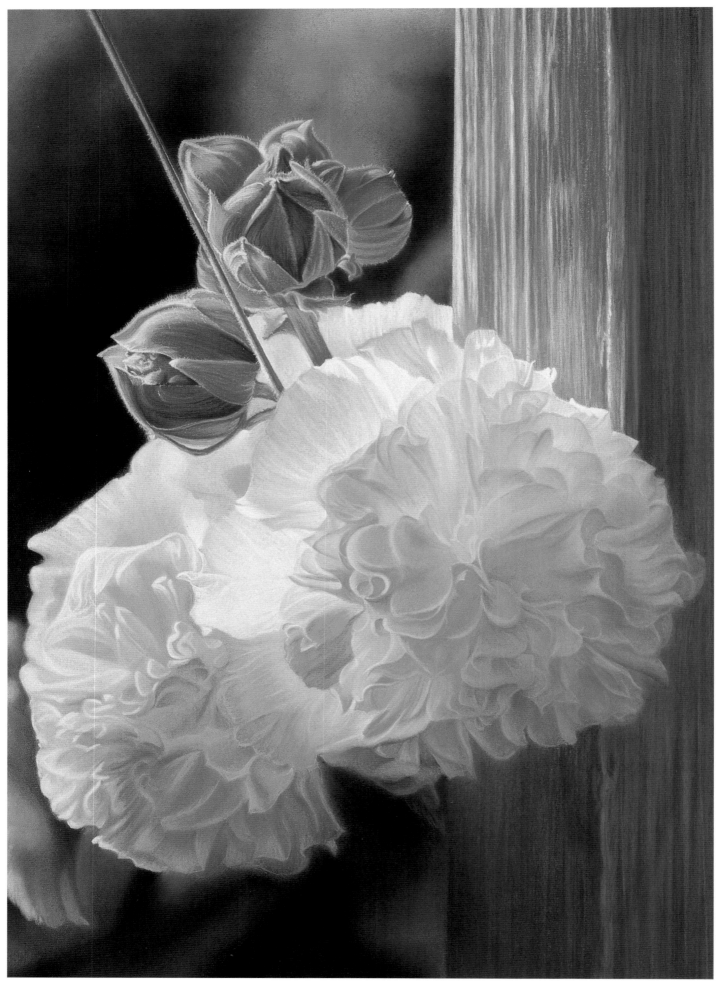

HOLLYHOCK 1
Miciol Black, soft pastels on charcoal paper
19" × 14" (48.3cm × 35.6cm)

Flowers. The quintessential metaphor for pristine beauty that is poignantly transient. But it is that very transience (perhaps because it reminds us of ourselves) that makes the beauty of a bloom so intriguing. Artists of all eras have tried to capture their temporal elegance or charm. Flowers offer us an infinite variety of shapes and colors, for not only is there an unending number of species for us to explore, but each individual bloom is unique in its own right. Combine all of those wonderful colors and shapes with the marvelous textures and scents, add sunlight and your own feelings, and you have a lifetime's worth of painting subjects.

In fact, because some of you may feel there is indeed an overwhelming array of subjects and ideas to choose from, we have tried to clarify a main theme or emphasis for each of the paintings in this book. We hope this will help you understand the many ways you can, in practical terms, transfer those beautiful flowers into beautiful paintings.

The categories into which we have decided to divide the works of art in this book are shown in the chapter titles. Obviously, most of the paintings make use of more than one of the elements listed in the chapter titles; some make visual use of all of these elements. But in almost all cases, it seems that one element is emphasized above the rest. So, we see that deciding on a main "theme" (such as texture, color or light) will help you organize a flower painting that has a clear focus and remains interesting and inspiring to the viewer.

I hope this book is enlightening to you, as well as an inspiration. I have, with the help of the contributions of many of the artists, included some quotations that I hope will encourage and touch you as much as they have me. Keep on painting, and don't forget to smell the flowers!

More than anything, I must have flowers, always, always.

—CLAUDE MONET

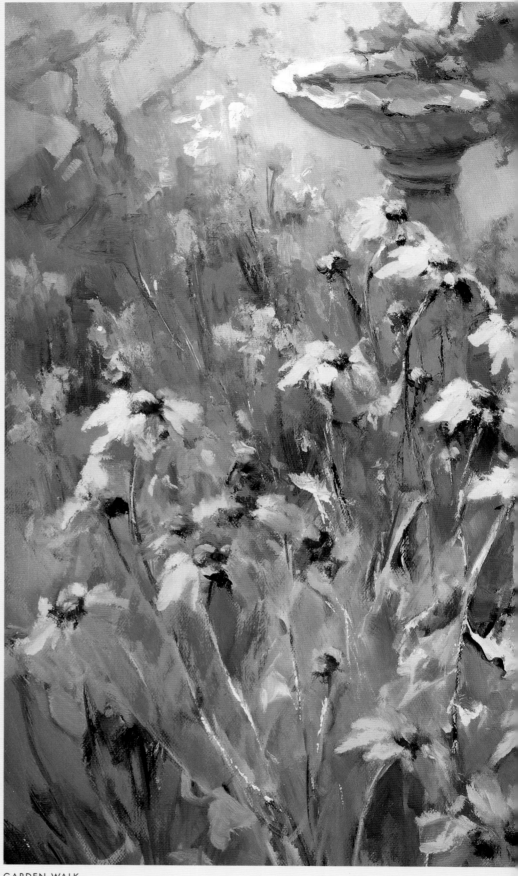

GARDEN WALK
M. Laubhan Yanke, oil on linen canvas
22" × 28" (55.9cm × 71.1cm)

1

Emphasize Design and Composition

A bit of fragrance always clings to the hand that gives you roses.

—CHINESE PROVERB

A ROSE IS A ROSE
Robert J. Kuester, oil on canvas
30" × 40"(76.2cm × 101.6cm)

Success With a Forbidden Composition

LOIS GRIFFEL

I love to paint the quaint houses and grayed, weather-beaten fences in my hometown, especially when they are contrasted by the colors and contours of our abundant gardens. The sharp edges created by the architecture are important elements in the composition, while the flowers and foliage add important variety. I particularly wanted to paint the dappled light on the house, as well as on the lilies in the background. This unfortunately divided the square format into four equal parts. I decided to challenge a painting "no-no" by carrying the eye past the dead center of the painting with the repetition and movement of the rounded forms of the foliage. The composition becomes a dynamic between soft and sharp. **TECHNIQUE:** Despite the fact that this turned out to be a successful painting, it could have been a disaster. It taught me to plan my compositions more carefully with quick preliminary sketches, and to always bring different shaped canvas along to every location.

SUMMER LILIES
Lois Griffel, oil on canvas
20" × 24" (50.8cm × 61cm)

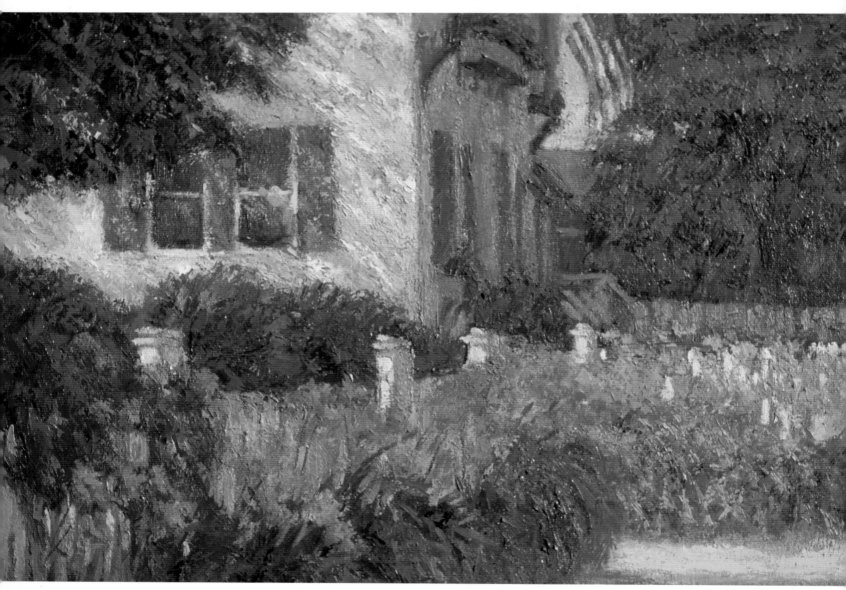

And which of you by being anxious can add one cubit to his span of life?

Consider the lilies of the field, how they grow; they neither toil nor spin;

yet even Solomon in all his glory was not arrayed like one of these.

—MATTHEW 6:27-29

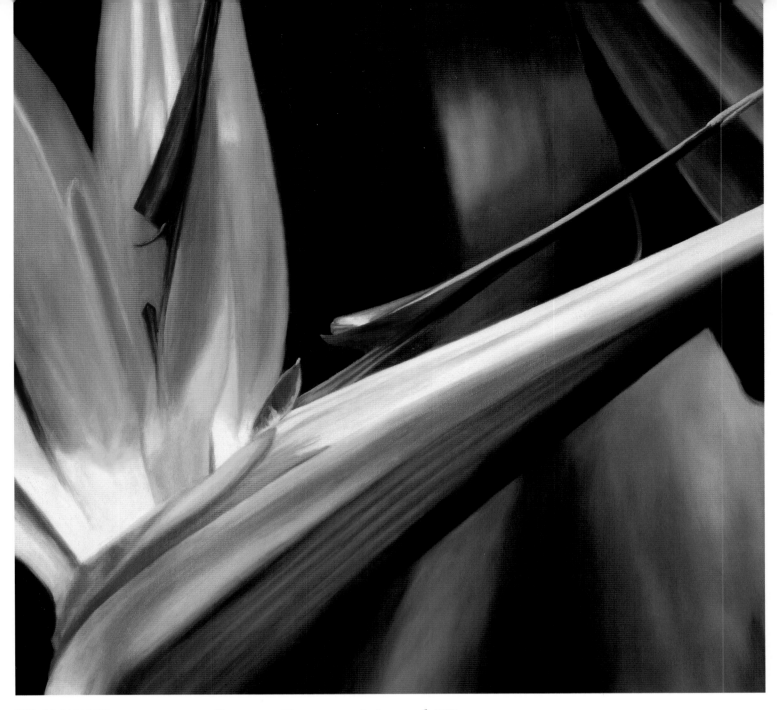

BIRD OF PARADISE
Katherine Bleser, oil on linen canvas
32" × 32" (81.3cm × 81.3cm)

Some Compositional Tips
for More Dramatic Paintings

KATHERINE BLESER

A painting of a single flower can be made more dramatic by using creative composition and color. Here are some composition tips for dramatic paintings: The flower's center should not be in the center of the painting. The flower should fill most of the space. Parts of the flower, as well as leaves and stems, should be cut off by the edges of the canvas or paper. Here, dynamic movement is suggested by the strong diagonal lines and by showing the various flower parts growing out from the center of the flower. I like oil paint for floral paintings because the oil colors capture the rich colors of flowers. With oil it is possible to depict the textures of the petals, whether transparent or opaque, shiny or matte. **TECHNIQUE:** The oil colors I use for painting flowers are: Cadmium Yellow, Cadmium Red, Winsor Violet, Alizarin Crimson, Permanent Rose, Cobalt Blue and Titanium White. Mixing Alizarin Crimson with Cadmium Yellow creates a vibrant orange. To tone down the flower colors, and to get the flowers to blend in with the background greenery, I mix in a little Sap Green. Sap Green and Viridian are the only greens I use.

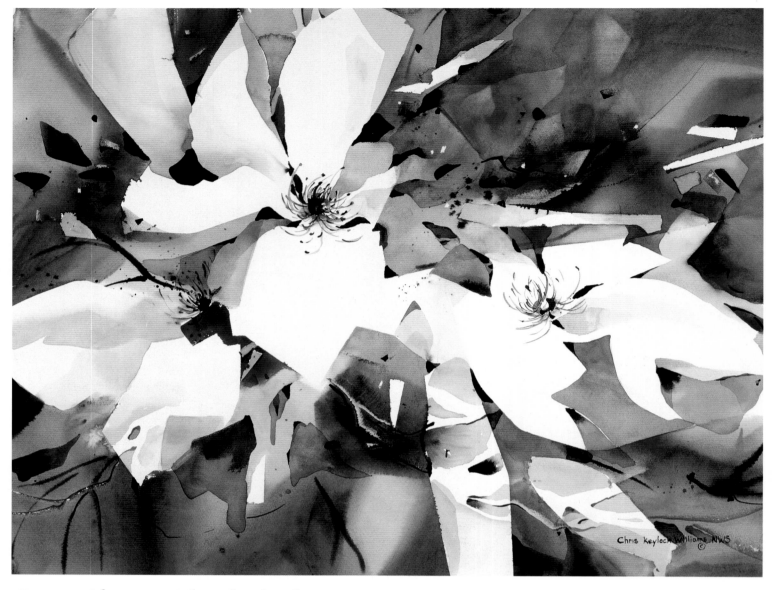

Paint Abstract Floral Rhythm

CHRIS KEYLOCK WILLIAMS

For me, the essence of flowers is in the rhythm of abstract shapes and designs. I studied the clematis, analyzing its structure, size, the design of the stamens and the feeling of movement as it's draped on the trellis. In *Bow Ties*, the large clematis blooms overlap and connect with one another, while the leaves and vines create a secondary set of patterns behind the blossoms. **TECHNIQUE:** To set the stage, I placed six to eight fairly rectangular pieces of wax paper in a pleasing, overlapping arrangement on my watercolor paper. I then used masking tape all around their edges and added a few additional scraps of torn masking tape to the design. I then did a juicy, colorful wet-into-wet underpainting with my loaded brush skipping across the masked-out areas. After the paint dried, I removed the tape and wax paper and developed the painting.

BOW TIES
Chris Keylock Williams, watercolor on 140-lb. rough paper
21" × 29" (53.3cm × 73.7cm)

Let a Bouquet Stretch Beyond the Rectangle

JAMES M. SULKOWSKI

The antique classical urn inspired the concept of this painting. It was essential to capturing the "mood" of the overall subject—the feeling of a rich, colorful bouquet of flowers resting on an outdoor garden ledge. I arranged this abundant bouquet to give the feeling that it isn't confined by the rectangular shape of the panel, but continues outward and beyond. This serves to energize the design and makes us feel we are looking through a window where there is yet more to discover. The classical antique urn denotes a garden setting; the blue sky and cool, pale green background enhance the outdoor effect. **TECHNIQUE:** I grind my pigments with specially prepared oils to give me rich color and the control I need to manipulate the paint. I always work from fresh flowers, either from my own garden or my local florist's shop.

FLORAL WITH ANTIQUE URN
James M. Sulkowski, oil on panel
36" × 24" (91.4cm × 61cm)

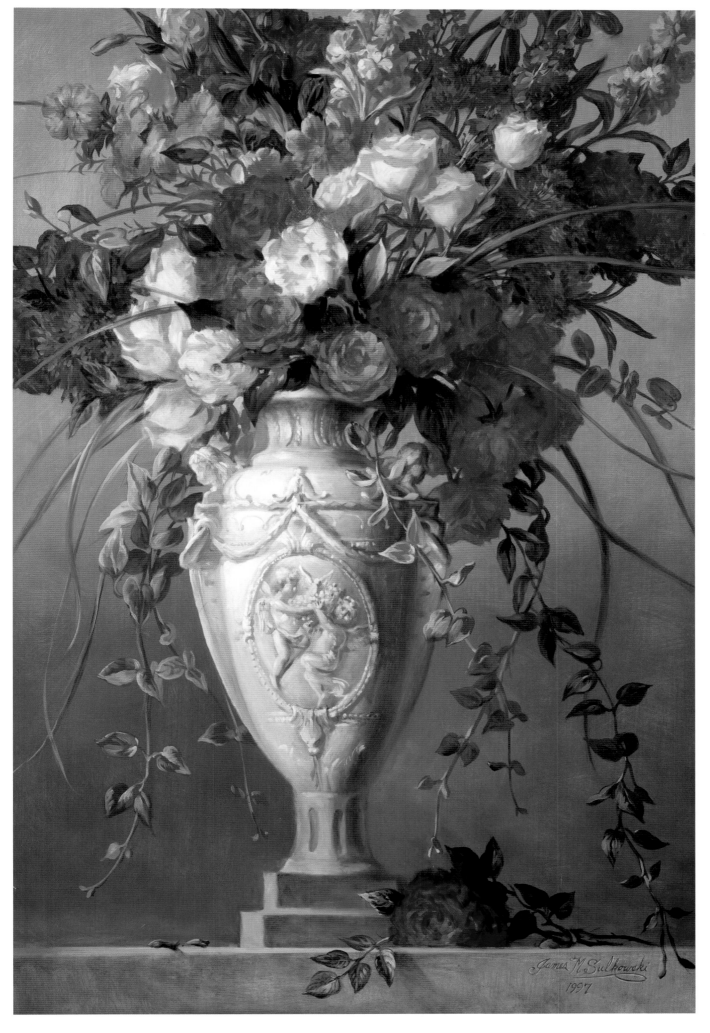

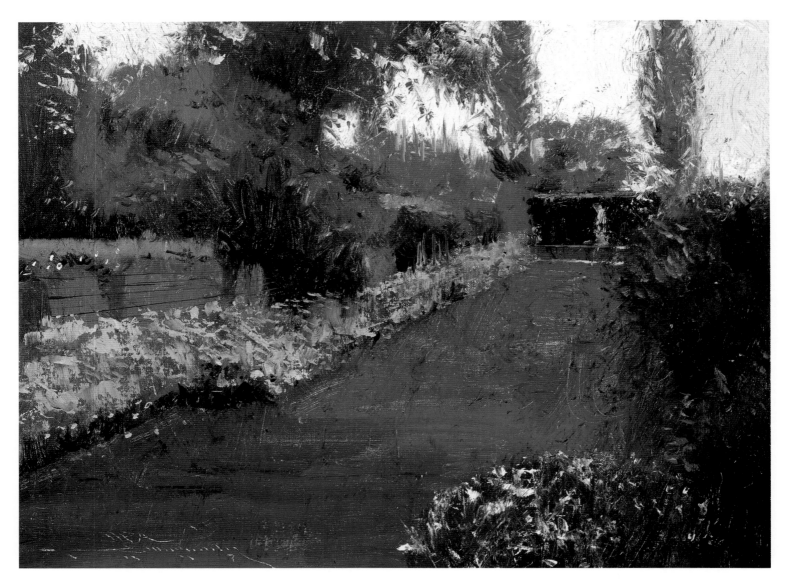

Keep Your "Anchor" in the Golden Section for a Tried and True Design

CHARLES WARREN MUNDY

A painting can only be as good as its design. I take great patience in designing my paintings when I'm out on location. All the vanishing point lines lead directly to and through the golden section. I've used my darkest dark as a rectangular shape to be my anchor in the golden section. The classic design of this view along with the wonderful feeling of peacefulness in this famous garden in England were my inspirations. The long border of light purple flowers complemented and united the family of colors in the entire painting. Even the grayish overcast sky added greatly to the unification of this painting. **TECHNIQUE:** This painting was one of seventy-six I painted in England in the summer of 1997. I painted all of them en plein air, alla prima. I found myself making more use of the palette knife in combination with brushwork to suggest the flowers.

GARDEN AT SISSINGHURST
Charles Warren Mundy, oil on double primed linen canvas
9" × 12" (22.9cm × 30.5cm)

Dual Nature of Nature— Contrasting Forms

MICIOL BLACK

While painting this flower, the contrasting forms of the flowers and leaves intrigued me—the multiple straight, "spiky," star-like petals contrasted with the convoluted undulating form of the leaves and the fuzzy round center of the flower. The bright glowing color of the daisy advances, while the green leaves recede and fade into the background. **TECHNIQUE:** This painting was one of the first pastel paintings I tried on La Carte pastel card. I found that it was a bit difficult to keep from smearing the background colors into the foreground. Extra care had to be taken. When blending on La Carte, it felt like the pastel was "rolling around" on little beads.

GERBER DAISY
Miciol Black, soft pastels on La Carte pastel card
17" × 12" (43.2cm × 30.5cm)

Design the Inner Garden of the Imagination

ELIZABETH GROVES

Using bright color in a controlled composition, I attempt to show the delight I always find in my garden. The watercolor process, for me, transcends the actual garden. I believe we are most creative when we express the inner gardens that flourish within the imagination. **TECHNIQUE:** The challenge in composing the elements in *Veronique's Garden* was to divide the format as interestingly as possible into a geometrical, yet symmetrical, scheme. Everything is arranged around the vertical and central thrust of the sunflowers. Then, by an exaggerated use of vibrant color and many glazes, I attempted to create a mood of excitement. This painting is strictly an imaginative exercise. The flowers are not real, nor are the colors.

Keep Major Value Shapes in Mind

ROBERT J. KUESTER

This still life began, as most of mine do, with a casual placement of favorite objects and then a search for meaningful abstract shapes. I first saw a "question-mark" shape in the white flowers, which was connected to the vase and the tablecloth. When I added the basket, it extended the background values into the foreground in an interlocking arabesque of two major value shapes. **TECHNIQUE:** Lighting here was artificial using a 3200° halogen with a medium blue photographer's filter and diffuser to simulate north light. This may aid some artists who lack the luxury of north light.

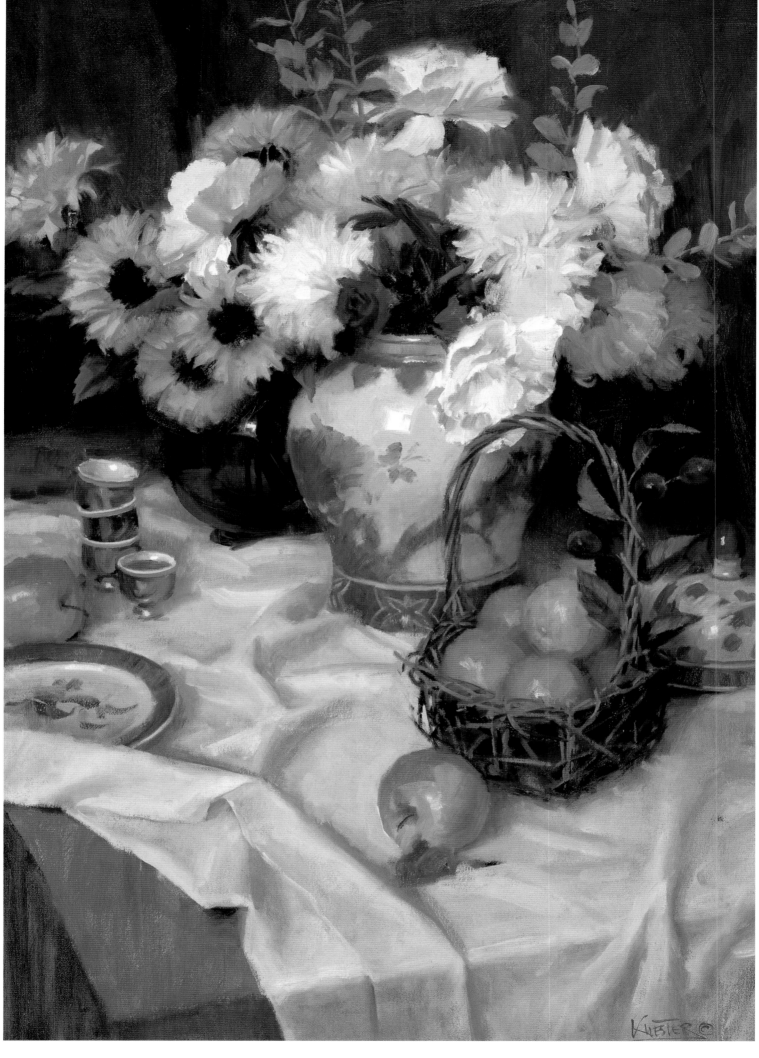

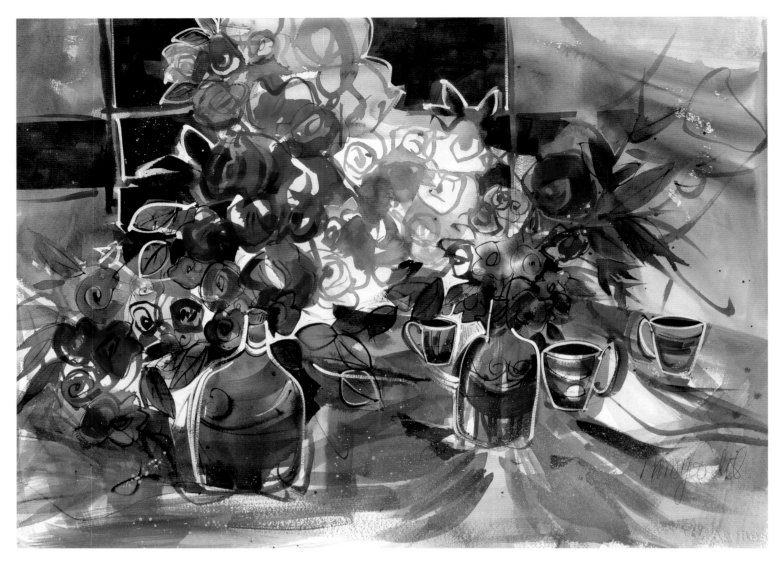

Let Your Painting Suggest Its Progress

NANCY CONDIT

An explosion of a rose flower design coming from light was the inspiration for *Morning Tea*. Without planning too far ahead, I relate to the painting and the process as I move along spontaneously. This painting began with a wet-into-wet background. I allowed it to dry, and it then suggested where my next passages would be. The suggestion of a table and the placement of the bottles and tea cups came next. The morning tea I was drinking then became part of my painting. **TECHNIQUE:** About two-thirds of the way through, I placed a white mat around the painting. I stepped back (or put the painting on the floor) to analyze the values. My last thought was to include the intense Indigo Blue panels to add a dramatic contrast.

MORNING TEA
Nancy Condit, watercolor on Arches 140-lb. cold-pressed paper
21" × 29" (53.3cm × 73.7cm)

Swirls of Abstract Pattern Reveal Perfect Realism

BARBARA EDIDIN

I strive for a balance between realism and abstraction. My work is perfectly realistic, but on first sight one might see just a swirl of abstract pattern and color. Then out of that swirl emerges objects that are recognized as being absolutely realistic. The eye bounces back and forth between these two ways of seeing. Using reflective objects like the silver pitcher and complex patterns like the floral pattern scarves add to the effect. Although they add to the overall rhythm of the drawing, the flower blossoms themselves provide a resting place for the eye. **TECHNIQUE:** Colored pencils cannot be mixed on a palette as can paint, so all the mixing of colors must be done directly on the paper by layering different pencils. The same rule applies to light and dark values which are laid in first with black and various shades of gray. The colors are applied on top of this black-and-white drawing.

SWEET WILLIAM
Barbara Edidin, colored pencil on four-ply Strathmore 500 Series bristol, plate finish
23" × 16" (58.4cm × 40.7cm)

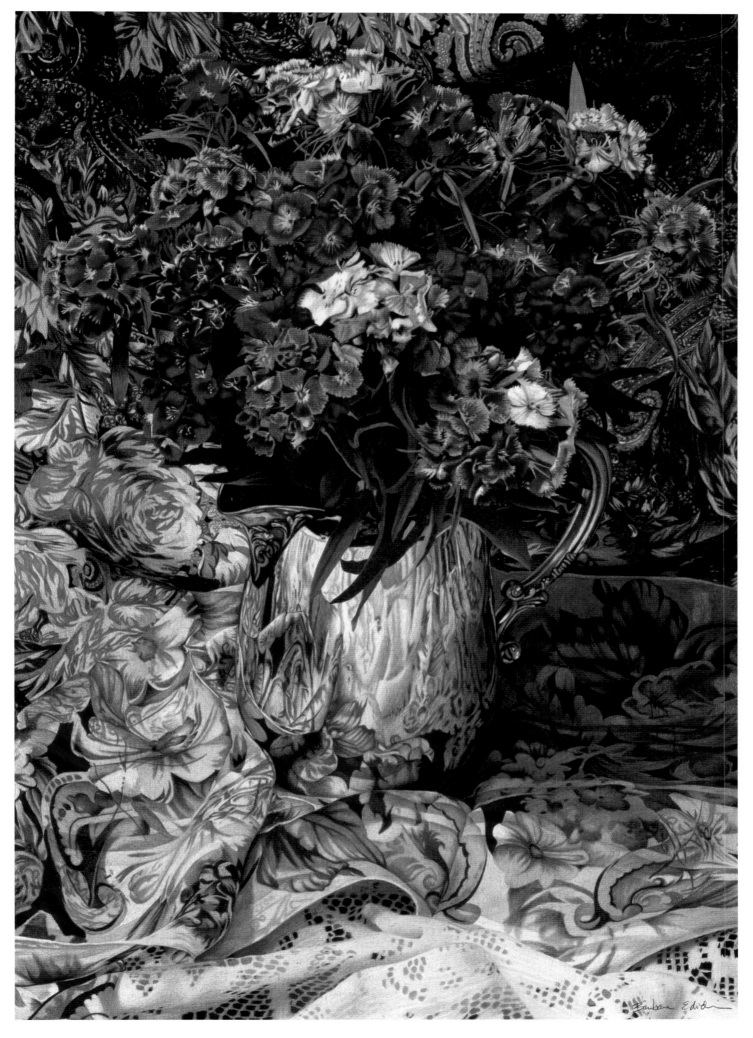

HERALDS TO SPRING
Judy D. Treman, watercolor on Arches 300-lb. rough paper
22" × 29" (55.9cm × 73.7cm)

Accentuate Color

I perhaps owe having become

a painter to Flowers.

—CLAUDE MONET

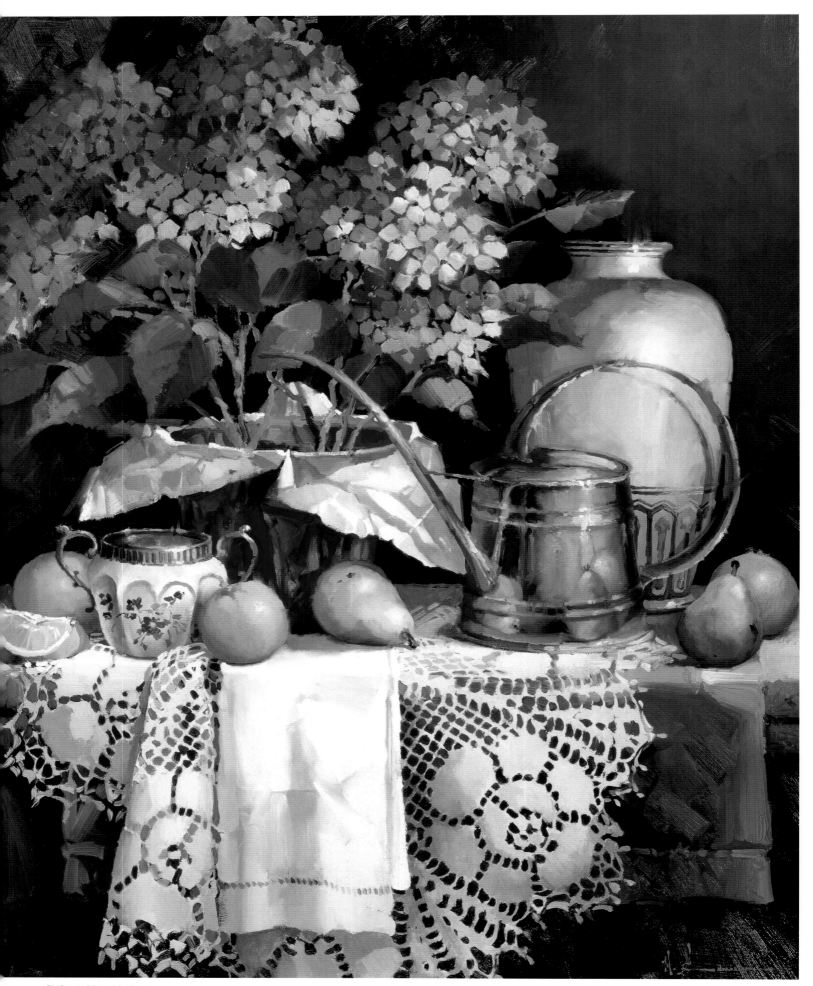

THE WATERING CAN
Marla Edmiston, oil on wood panel
36" × 30" (91.4cm × 76.2cm)

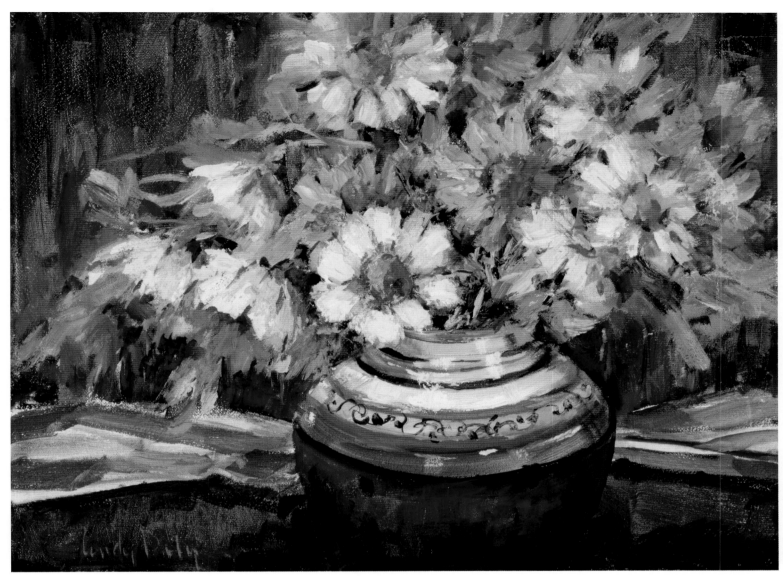

Try "Shock" Accent Colors

LINDY DALY

I've always loved Van Gogh's *Sunflowers*, and I was recently inspired by a set-up of sunflowers by contemporary artist Howard Carr. When a neighbor had an excess of sunflowers in her garden, I happily took them off her hands. I set a bouquet of these bright yellows against a backdrop of their dulled complements, violets and purples. Rather than using Yellow Ochre directly from a tube, I mixed yellows with violets and purples for more variety and depth of color. While the complementary color scheme is emphasized, the use of a very few "shock" accent colors make the painting more exciting. **TECHNIQUE:** I set up a still life with a definite light source—from a window or a lamp, with all other lights lowered. In this way, you can "place" your shadows to advantage. After I blocked in the design with a soft flat brush and a thin coat of paint, I used a palette knife the width of the petals with a rounded tip and loads of paint. I also piled on the paint with a filbert bristle (also the size of the petals), then spread with the palette knife—and the filbert.

SUNFLOWER LANDSCAPE
Lindy Daly, oil on canvas
12" X 16" (30.5cm X 40.7cm)

Cool Blue, Warm Orange

MARLA EDMISTON

Every time I see the lovely hydrangea plants at the flower shops in the spring, they soon find their way into a painting. After locating a unique copper watering can in a gardeners' catalog, I decided to incorporate them both into a set-up. The complementary blues and oranges are the focus. The greens and neutrals act as a pleasant framework for this exciting color contrast. **TECHNIQUE:** I use Rembrandt Dutch Oil colors exclusively and superior quality hog bristle filberts and red sable round brushes. After sketching in the objects with a light wash, I lay in the background first, then the flowers. I proceed to work from the top down, completing each object before moving on to the next. To keep things fresh, try a simple "indication" with a few brushstrokes. Don't try to paint every leaf and petal.

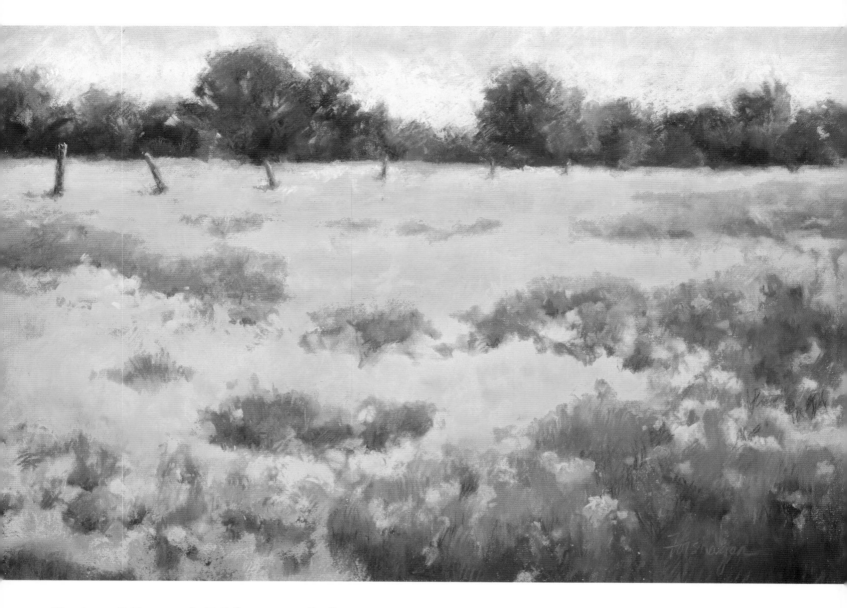

Paint Nature's Vibrant Color

MARY K. FORSHAGEN

Driving down Route 29 in Texas one afternoon, my friend and I came across a magnificent field of wildflowers. They screamed out to be painted. We plunked ourselves down on the side of the road to admire and paint this breathtaking scene. Even our sense of smell was heightened—wildflowers baking in the Texas sun.
TECHNIQUE: After completing an oil study in the field, I returned to the studio and my pastels to begin a larger painting. I chose the very versatile Wallis sanded pastel paper, dry mounted on museum board. I began by covering the white paper with complementary colors in very simple shapes, using hard pastels. Next, with water and a brush, I painted over the whole thing, creating a very loose underpainting. I began boldly applying the local colors with softer pastels, trying not to cover the entire underpainting. My two main yellows were Unison (Brand) Additional Color #12, a very intense deep yellow-orange, and Sennelier #198 Cadmium Yellow Orange, which is slightly cooler and lighter.

TEXAS GOLD
Mary K. Forshagen, pastel on Wallis sanded paper
14" × 21" (35.6cm × 53.3cm)

Balance Intense Warm Color With Other Warm Colors

LOIS GRIFFEL

The brilliant sunlight illuminating the lilies was a real attention grabber and immediately became the focus of my painting. However, because the dramatic light was intensifying what was already the warmest colors in the composition, I had to be careful not to let the lilies totally take over. I balanced these intense oranges by warming up the pink roses in the foreground, which invites the viewer into the painting. This step allowed me to retain the intense warm colors in the sunlight, keeping the composition balanced and exciting. **TECHNIQUE:** In order to warm up the Permanent Rose used for the roses, I mixed Cadmium Scarlet, matching the richness and value of the first note. By lightly layering (or scumbling) the two colors over one another, allowing the bottom color (Permanent Rose) to show through, the scarlet warmed the rose without significantly altering it.

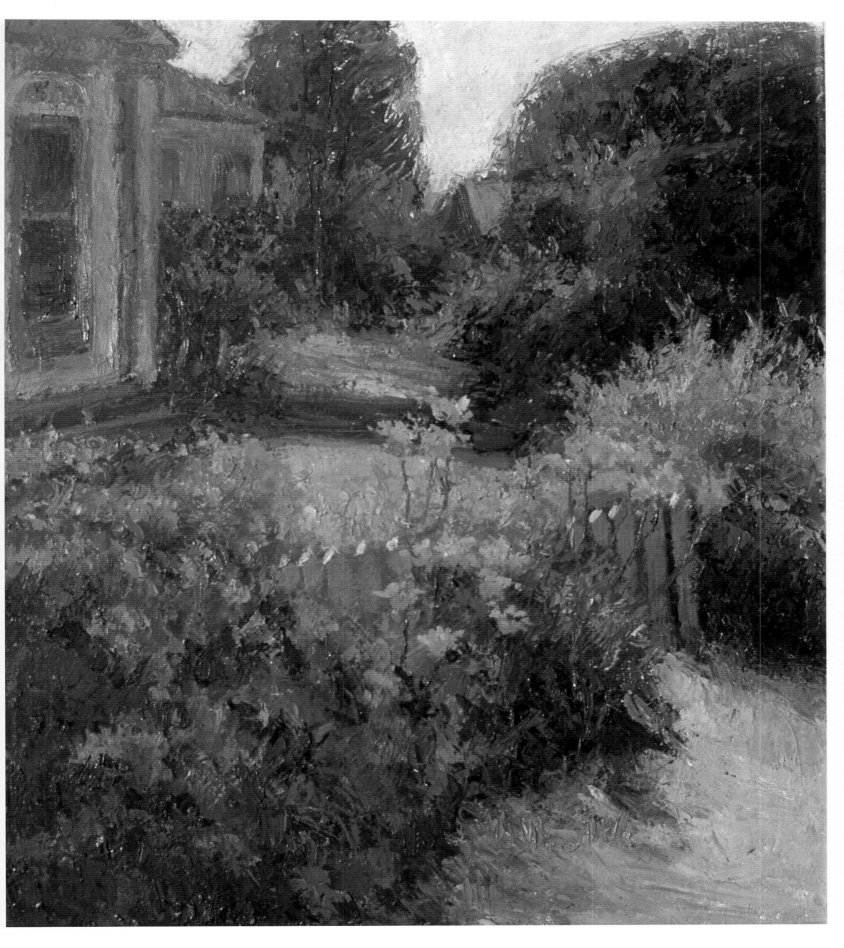

DRAMATIC LIGHT
Lois Griffel, oil on Masonite
21" × 19" (53.3cm × 48.3cm)

Capture Personality as Well as Form

CAROLE KATCHEN

One of the things I love about living in Arkansas is being able to grow wonderful flowers in my own backyard. For this painting I picked lush branches of crepe myrtle, a few stems of sweet peas, a sprig of wisteria, some coreopsis and one big stargazer lily for a focal point. The crepe myrtle, sweet peas and lily are all pink, giving unity to the overall color. The violet wisteria blends well, and the yellow coreopsis provide a needed contrast. When I paint a flower, I think of it as a portrait and try to capture its personality as well as its form. **TECHNIQUE:** This piece was done with many layers of blended color. All the edges are blurred except for a few blossoms I wanted to emphasize. Those few specific edges and details become more important in contrast to the blurred shapes.

SUMMER IN THE SOUTH
Carole Katchen, pastel
19" × 25" (48.3cm × 63.5cm)

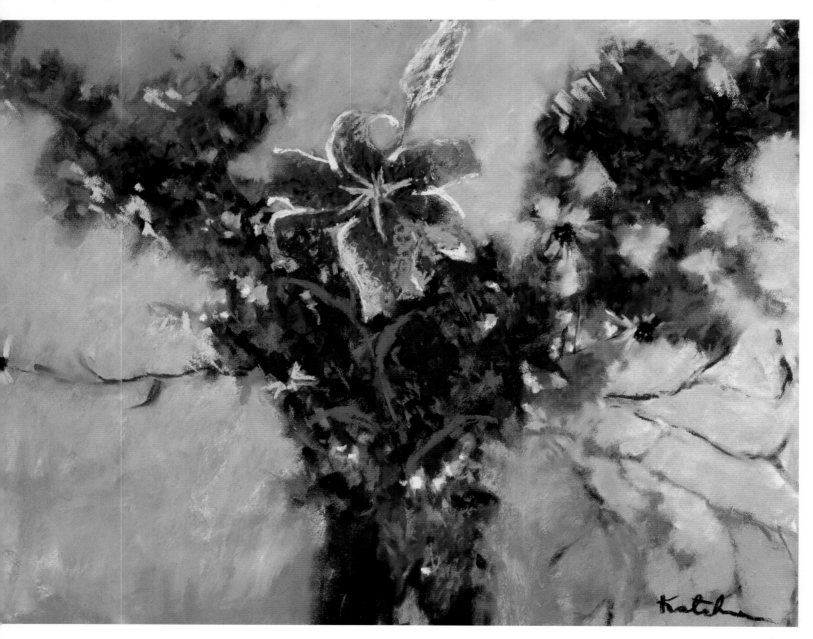

Harmonize Many Details into a Symphony of Color

MELANIE S. LACKI

You can say that gardening and painting are dual passions for me. Every spring I plant my gardens with a profusion of flowers in many colors and shapes. At the time this painting was created, I had a purple garden. That overwhelming color theme, and the static movement of the flowers, were the inspiration for this painting. By maintaining the purple color theme throughout, I was able to harmonize the many details and pull the many small shapes together. **TECHNIQUE:** This painting was executed in a traditional method, with transparent watercolor on watercolor paper. I used many glazes to achieve the depth of color in most of the flowers. A touch here and there of liquid masking fluid was used to preserve some of the white areas.

Forgiveness is the fragrance of the violet

which still clings fast to the heel that crushed it.

—FROM THE POEM "FORGIVENESS" BY GEORGE ROEMISCH

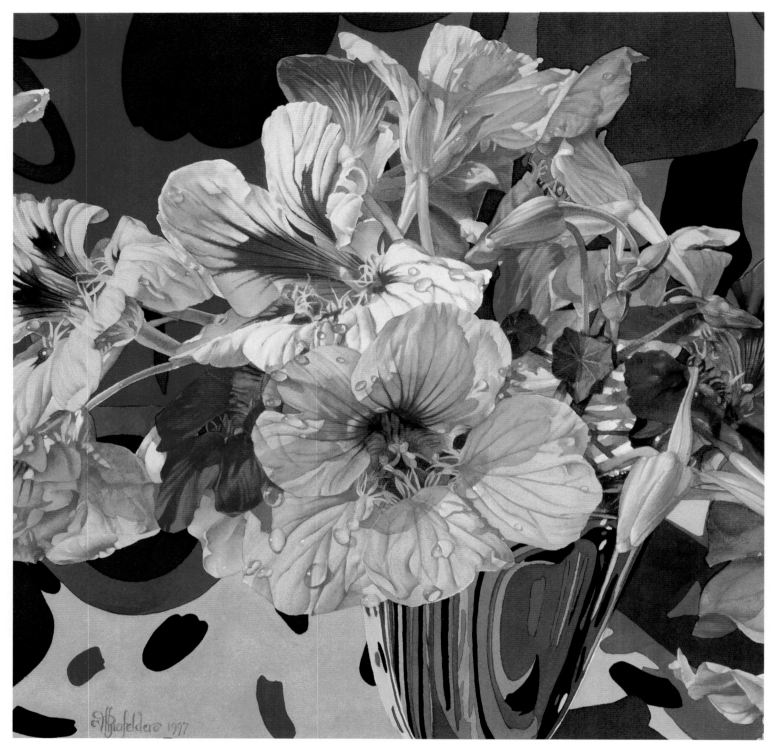

Focus on Primary Colors for Brash Joy

VIVIAN R. THIERFELDER

An explosive bunch of blooms, this is a straightforward, "in-your-face" blast of color and form that transmits joy and brashness. The use of mainly primary colors increases that bold effect. Nasturtiums, the painting's subject, grew last year in an unloved patch of ground, but seemed to flourish on neglect. I completed the work during a cold snap in January, hoping it would raise the studio temperature a few degrees! **TECHNIQUE:** The use of transparent watercolor emphasized the subject's brightness and vibrancy. For the yellows I used Aureolin and New Gamboge for their clear staining qualities.

BOOGIE
Vivian R. Thierfelder, watercolor
on hot-pressed paper
9" × 9" (22.9cm × 22.9cm)

SPRINGTIME CELEBRATION
Sandy Delehanty, watercolor on
Arches 140-lb. rough paper
22" × 28" (55.9cm × 71.1cm)

Contrasting Colors Dance With Energy

SANDY DELEHANTY

While enjoying a warm spring day in my flower garden, I noticed the way the colors seem to dance with an energy all their own. This energy seemed to be coming from the contrast in colors of the deep purple irises and the glowing copper-colored irises and the patterns made by the light and shadows. I thought it would be fun to try to capture this feeling of energy in a painting. Sitting on the grass, I "zeroed in" on the hummingbird view of my flower border. I created my composition by studying the relationship of the colors, the shapes, the patterns of dark and light, the textures, and the negative space between the flowers. My goal was to create a painting that glowed with energy—a painting that would become my *Springtime Celebration*. **TECHNIQUE:** I began by applying clear water on a petal, drawn on tightly stretched rough paper. Next, I dropped in a sedimentary color. Then the fun part—I dropped additional transparent color into that same puddle and watched the colors mix. I was careful to "tickle" not "paint" the colors. "Tickling" brings out the natural glow and energy that comes from letting the colors mix themselves in the water. As if assembling a jigsaw puzzle, I applied my color petal by petal, leaf by leaf, across the entire painting. The final touches on each flower included lifting and calligraphy techniques.

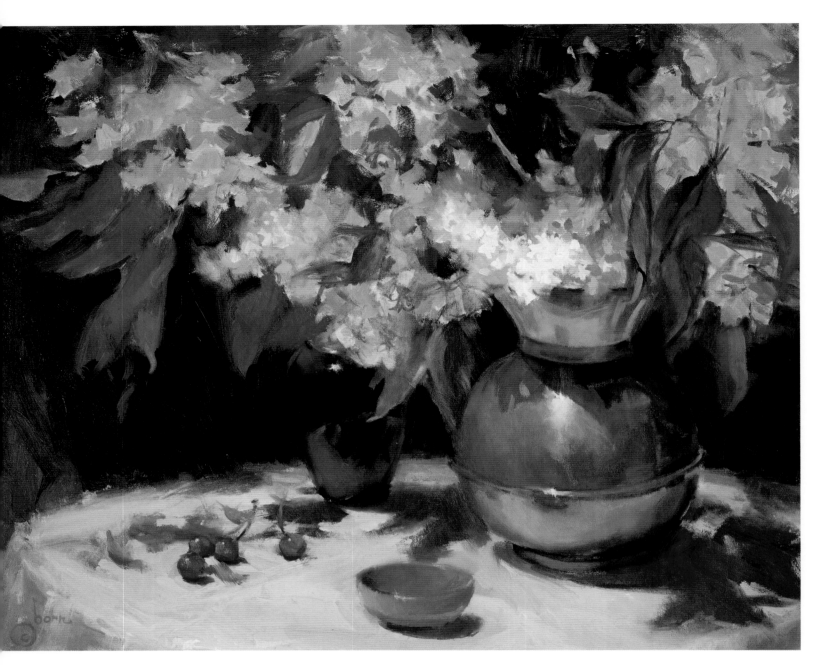

Surprising Pink Wakes the Senses

ANNE MARIE OBORN

In spring, the bountiful Utah hillside where I live becomes a lavishly adorned fairyland of cherry blossoms. I attempted to capture the soft, colorful reflection of these warm spring flowers in the shiny surface of an old brass spittoon, accenting this harmony with brilliant sunlight. The surprising "pink-ness" of the blossoms against the largely neutral-green painting suggests the pleasant jolt one experiences when coming across a field of these blossoms in nature. **TECHNIQUE:** If you look closely, you can see sections of the nearly bare canvas covered with only thin washes. Leaving these sections alone adds some spice of surprise along with the thick opaque areas of the painting.

ORNAMENTAL CHERRY BLOSSOMS
Anne Marie Oborn, oil on canvas
24" × 30" (61cm × 76.2cm)

Celebrate a Carnival of Color

JOE ANNA ARNETT

In Venice, I became infatuated with the carnival masks in the shop windows. The forms, colors, shapes and designs were so inviting and magical that I shipped several home to use in my paintings. When my irises bloomed the following spring, I felt that this explosion of color belonged with the masks. Carnival is, after all, a time of riotous color, celebration, and joy. **TECHNIQUE:** The irises in *Carnival* were painted with exuberant brushstrokes, using a large brush and keeping the paint thick and rich. I work only from real flowers, and the urgency this creates gives the painting life. The knowledge that they will wilt quickly keeps me from becoming so involved with details that I lose the sense of the whole form. For the bicolored irises, such as the yellow and white one in the front, I first modeled the petal in white and then painted the yellow frilled edges while the white paint was still wet.

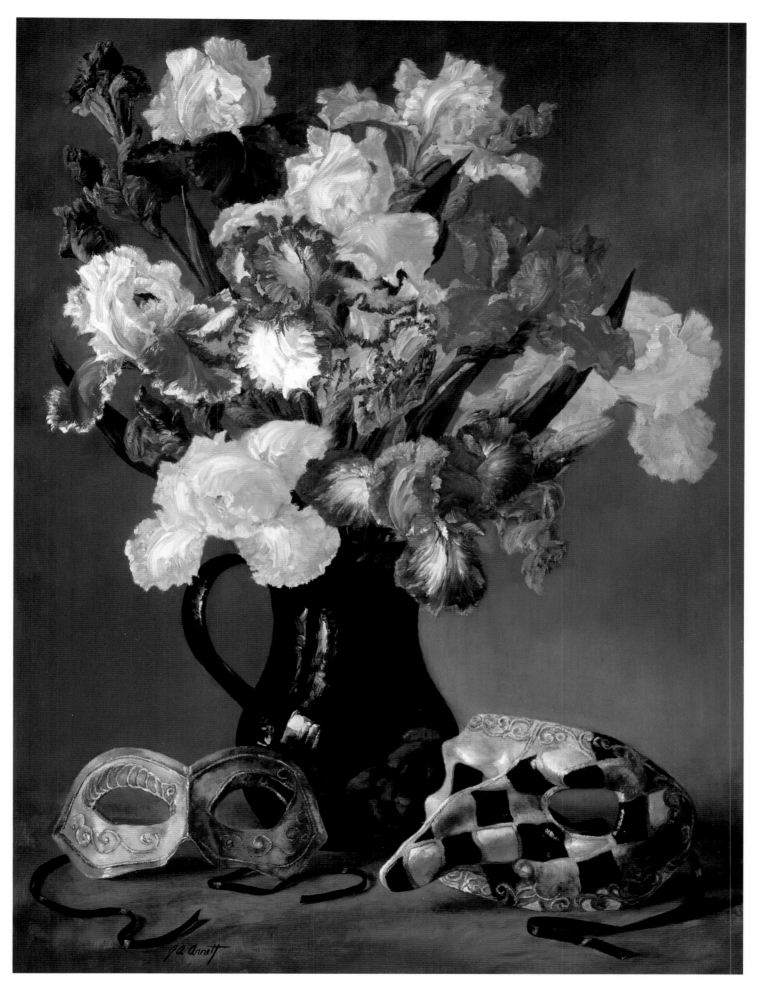

CARNIVAL
Joe Anna Arnett, oil on linen canvas
24" × 18" (61cm × 45.7cm)

Making Use of Every Kind of Red

ANNE BAGBY

COUNTRY RED
Anne Bagby, watercolor on
cold-pressed paper
7" × 7" (17.8cm × 17.8cm)

I began this painting with all the reds I could find—transparent fluid acrylics and opaque reds. Not only was I interested in the color but also the warmth of the red and the texture of the paint. I glazed and layered the reds going from transparent to opaque. I glazed the flowers back with a transparent green and then painted on top. I was trying to get the richest, reddest red I could get. To give the bunch of flowers volume, the bright flowers came forward and the duller flowers went back.

TECHNIQUE: I began this painting with a highly textured piece of paper I had patterned with sponging, brushes, drips and colored pencil and then glazed a bright red. While painting the picture, I was actually painting out the red. If you look closely you can see small specks of red throughout the painting. I painted the front flower Cadmium Yellow and then I glazed it with a cool red (such as Alizarin Crimson). This makes the brightest red I know and made the flower in front come forward. I shaded that flower with black.

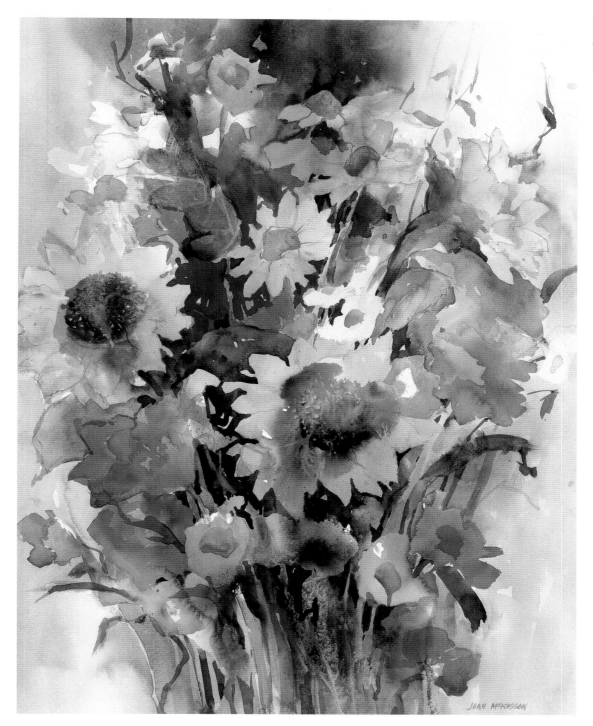

SUNFLOWERS IN THE GARDEN
Joan McKasson, watercolor on Arches
cold-pressed paper
26" × 20" (66cm × 50.8cm)

Celebrate Nature's Color and Variety
While Enjoying Your Watercolors

JOAN MCKASSON

The joyous color of sunny yellow sunflowers contrasted against deep green foliage was the inspiration for *Sunflowers in the Garden*. After adding some red flowers for variety in shape and color, I was enthused by the combination and vibrancy of the bouquet and was ready to paint. Adding complementary color in the background and the use of lost-and-found edges created the sense of mystery desired. **TECHNIQUE:** With my paper at a slight angle, I began painting the sunflowers and other shapes in clear water, creating an overall abstract wet design on the paper. Using Quinacridone Gold, I flooded rich pigment into the wet passages, added other yellows, reds and greens and allowed the colors to mix, run and drip, creating an exciting and emotionally involved beginning for my interpretation of the sunflower bouquet.

Nature Places Brilliant Color on a Neutral Backdrop

JOHN COX

People tend to think of the desert as dusty browns, grays and dull greens. Actually, it is alive with vibrant color, particularly in the spring. Being a landscape painter, I've always admired the brilliant colors of the desert flowers against the neutral colors of the desert floor. I've depicted this contrast in my cactus flowers. I usually work on a large scale, but by focusing on a single cactus, it allowed me to work in a smaller format. **TECHNIQUE:** I started by painting "organic" background on portrait linen. Then, using a liner brush, I painted the spines of the cactus. The blossoms were painted a minimum of three times with colors that are all transparent (except white). This creates the luminosity and brilliance characteristic of these flowers. Magenta, Permanent Rose, Violet, Transparent Red Oxide and Thalo Green are the main colors.

CACTUS COLOR
John Cox, oil on linen canvas
8" × 10" (20.3cm × 25.4cm)

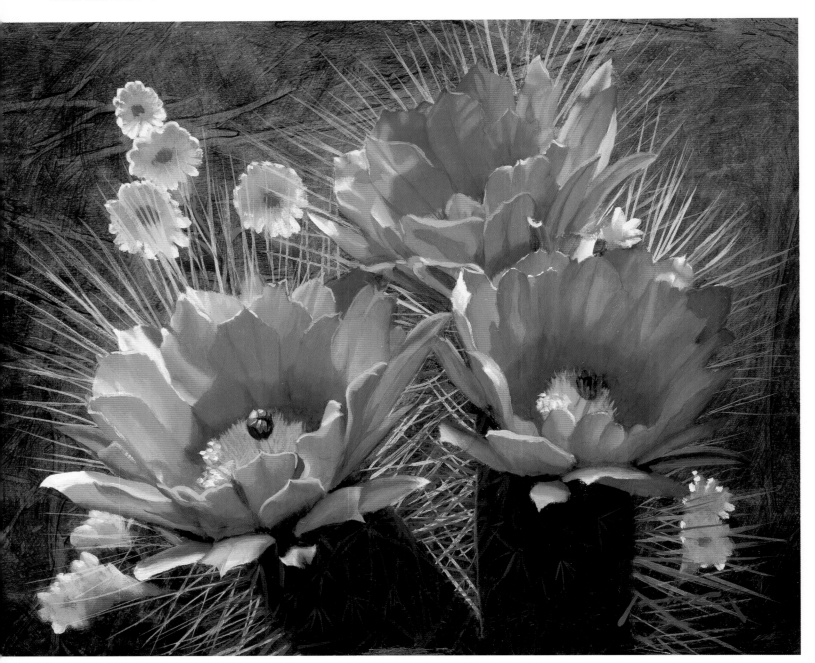

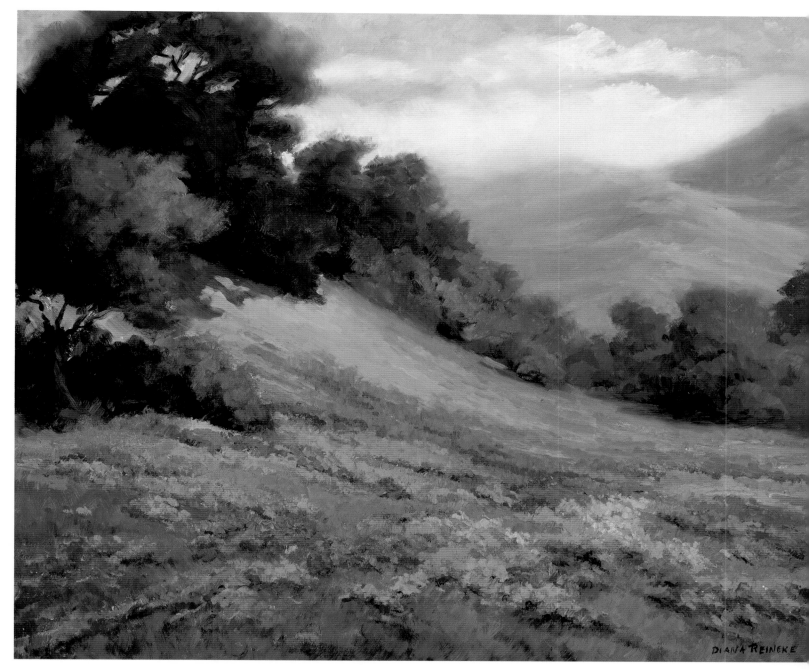

POETRY OF THE POPPIES
Diana Reineke, oil on linen canvas
20" × 24" (50.8cm × 61cm)

Finding a Treasure of Natural Complements

DIANA REINEKE

I still remember the day my fellow painter and I turned a corner and saw a mysterious orange glow that must have been a quarter-mile away. What we discovered was an entire field of poppies! I was awestruck. I had seen a smattering of poppies since moving to California, but this was unbelievable. The field glowed with an inner light that was spellbinding. As I wandered through the field looking for a place to set up my easel, I discovered blue-purple lupine zigzagging through the orange poppies. Nature never ceases to amaze me. I had found a perfect complement of colors! **TECHNIQUE:** I am a plein air painter; I make the inner connection with nature by being out in it. I usually paint quite small on masonite that I treat with gesso and an acrylic tone. By working small, I can put down the information I need before the light changes. This painting began as a 5" × 7" (12.7cm × 17.8cm) panel that was completed in the field, then re-created on a larger linen canvas.

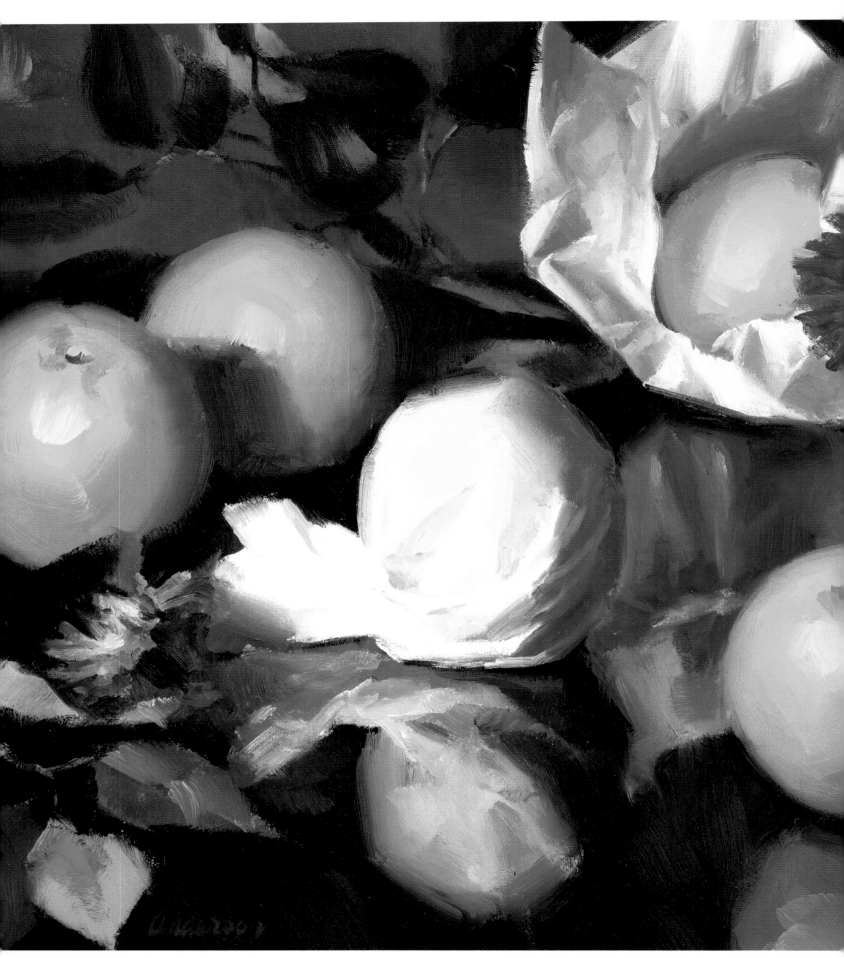

FIVE ORANGES
Kurt Anderson, oil on canvas
18" × 24" (45.7cm × 61cm)

Depict Texture and Pattern

I take as much trouble over

my fruits and flowers as I do

over my figures.

—CARAVAGGIO

A Stark Contrast of Colors and Textures

JANE JONES

Antheriums are the perfect flowers for this vase because of their strong similarity in color and difference in shape and texture. Their texture is waffle-like, their shape almost angular; both contrast to the smooth rounded glass. The flower's deep, rich redness is warm, while the deep red of the glass is cooler, as seen especially in the vase's cast shadow. Both reds contrast sharply with the stark white setting. I love the way light dances on and passes through glass, but to me the flowers remain the "star" because they are ambassadors of the beauty of nature. **TECHNIQUE:** I use the underpaint and glaze technique of the Old Masters to create contemporary images. This technique uses the luminous quality of the oil paint to its fullest advantage. Traditionally, a grayed color is mixed with white to create a value scale that is used for the underpainting. I prefer to use the overall color of the object mixed with white, so the flowers were first painted in light pinks and then glazed with layers of transparent reds.

ANTHERIUM
Jane Jones, oil on untempered Masonite
42" × 30" (106.7cm × 76.2cm)

"Camouflage" Your Subject

GLORIA MALCOLM ARNOLD

I enjoy featuring flowers combined with favorite glass and china collectibles. Alma, my husband's aunt, collected the Belleek china. Several things about the painting are unusual, including perspective, floral background and back-lighting. These features are designed to engage the viewer to interact with the painting. One has to search among the textures and patterns to discover how the three-dimensional objects relate to the floral fabric. **TECHNIQUE:** As a painter of realism, I create my oil paintings using sable brushes on a fine linen surface. I work in layers, first applying a transparent underpainting and building on this with opaque pigments. These techniques allow for greater control in the modeling of form. Be sure to establish a focus in a bouquet and have overlapping and interlocking shapes. This gives unity to the composition.

TEA WITH ALMA
Gloria Malcolm Arnold, oil on linen canvas
16" × 24" (40.6cm × 61cm)

Contrast Both Color and Texture

KURT ANDERSON

The objects in this painting—the oranges, tissue, red flowers and brass bowl—were chosen for their contrasting colors and textures. The greatest visual interest is created by the contrast between the variegated texture and the intense color of the tissue, and the spherical simplicity of the oranges. In a purely abstract sense these objects work together very well, and that is why they are a recurring theme in my paintings. **TECHNIQUE:** I like to use thick, opaque color for lighter foreground objects and thinner, transparent color for darker background and shadow notes. This textural contrast creates a real, though subtle, three-dimensionality. The tissue leaps forward because the paint itself sticks out beyond the background color. The lightest brushstrokes form ridges that pick up the light and create a slight shimmer.

WRAPPED ORANGE
Kurt Anderson, oil on canvas
20" × 16" (50.8cm × 40.6cm)

Try Painting over a Pattern for Added Texture

ANNE BAGBY

I first used acrylics to paint a red pattern on white paper. I then drew the sunflowers over to the right to avoid covering too much of this pattern, but this looked very unbalanced. So I added the fish bowl, since I wanted something clear to allow the pattern to be seen. The apples give the painting scale—they make the sunflowers look very large. The composition was too crowded, so I glazed out the red pattern with a transparent dark green so that the pattern only shows inside the fish bowl. The transparent dark still gives just a hint of the design, whereas an opaque would have completely covered it. **TECHNIQUE:** I painted the flowers with whites and creams, and glazed over the sunflower with transparent golds. On top of this I put some opaque yellows for a change in texture. I was trying to make the sunflower just as bright as I could.

GOLDEN DELICIOUS
Anne Bagby, watercolor on cold-pressed paper
7" × 7" (17.8cm × 17.8cm)

I am going to cover the white walls of the room that you will sleep in with nothing but paintings of large yellow sunflowers.

—VINCENT VAN GOGH

SUNSET
Heidi J. Klippert Lindberg,
colored pencil on cold-pressed
illustration board
18" × 15" (45.7cm × 38.1cm)

Create a "Tactile" Experience in Shapes and Textures

HEIDI J. KLIPPERT LINDBERG

Even as a flower fades, it possesses great beauty, drama, movement and mood. Using colored pencils for their clean pure colors and control, I try to create a visual "tactile" experience for the viewer. As I trace the subject with my eyes, I physically press the colors together and almost "feel" every surface, shape and texture. The painting evolves from the inside out as I go over and over each minute part. The result is often something I could never imagine, an abstract realism. **TECHNIQUE:** Ever mindful of the principles of design, I create the composition in my own photographs and refine it on cold-pressed illustration board. My technique is to lay down a heavy base of color by abusively grinding and mixing the pigments directly on the board. A razor blade is a secret weapon for correcting errors. To bring out the color and protect the finished painting, I spray a copious layer of fixative.

No, the heart that has truly lov'd never forgets / But as truly loves on to the close / As the sunflower turns on her god, when he sets, / The same look which she turn'd when he rose.

—THOMAS MOORE

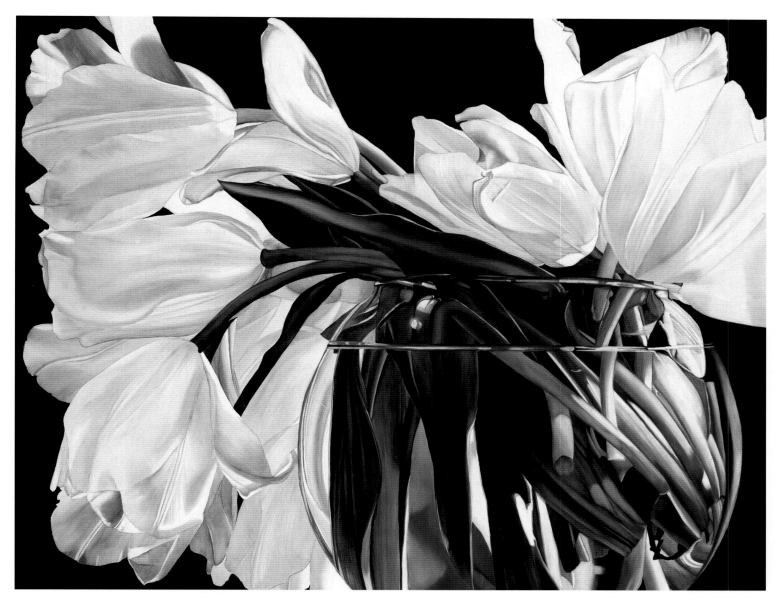

ILLUMINANT
Sandra Sallin, oil on canvas over panel
14" × 18" (35.6cm × 45.7cm)

Explore Crystal Reflections and Refractions With Regal Flowers

SANDRA SALLIN

For some time, I have found the experience of painting white flowers with a black background compelling. The whites of the flowers emerge from the shadows to radiate and suddenly confront the world. My choice of flowers is not arbitrary. The flowers must evoke a feeling of history and emotion; thus, the flowers I usually paint are lilies, roses and tulips. Lilies represent purity, peace and royalty. Roses symbolize both perfection and earthly passion. The tulip is the Persian symbol of perfect love. **TECHNIQUE:** To begin, my canvases are gessoed and sanded between thirty and forty times. The velvety finish that is created feels much like the petal of a flower. When this series of black-and-white paintings was begun, I looked for new oil colors to transmit this vision of glowing whites. Lefranc & Bourgeois and Winsor & Newton had always been primary choices, but I now added Old Holland and Schmincke. Their unusual colors, like Schmincke's Warm Gray, Cool Gray, Brown Pink and Raw Sienna, were mixed with their transparent paste. Among other colors used were Old Holland's Transparent Oxide Yellow Lake and Old Holland Yellow Deep. Each petal is finished one at a time and virtually becomes an individual painting. After applying the paint, I brush the excess away, leaving the white of the gessoed canvas to glow through the very fine layer of pigment. It is a reductive process, resulting in floral images infused with an inner light.

Try Painting Over an
Old Painting for Added Texture

ANNE MARIE OBORN

This work was inspired by a specific request to paint purple allium. My initial response was, "No, not purple allium." Allium are so perfectly spherical, so symmetrical, that I thought I'd never be able to paint them without a "clownish" result. This initial reaction was followed by the idea to create this challenging painting over a previous failure. I also added a number of varied objects to accompany the lone allium. **TECHNIQUE:** A traditional realist, I enjoy using an alla prima technique, painting my florals all at one time in the natural sunlight. By making use of the colors and textures of the previous painting, I was able to enhance the end result. You can see the underpainting come through in the dark background at the upper right-hand corner and in parts of the table.

PURPLE ALLIUM
Anne Marie Oborn,
oil on gesso/Masonite
20" × 24" (50.8cm × 61cm)

WHITE LILIES
Charles Warren Mundy,
oil on double-primed linen canvas
20" × 16" (50.8cm × 40.6cm)

Consider the Texture of All Edges

CHARLES WARREN MUNDY

The strong white light on the lilies with their hard edges took front stage from the very soft-edged brass vase and the glass vase. I took great effort in being only suggestive in the vases and with the background flowers. The light accents on the vases counterbalanced the light values in the lilies. **TECHNIQUE:** I used tissue paper to break into the edges of brushstrokes. This added softness and texture to the edges. Edges must have their proper relationships in painting, just like color and value—look at the relationship of edges on the white lilies and on the hot spots on the vases. Notice, some are textured and some are not.

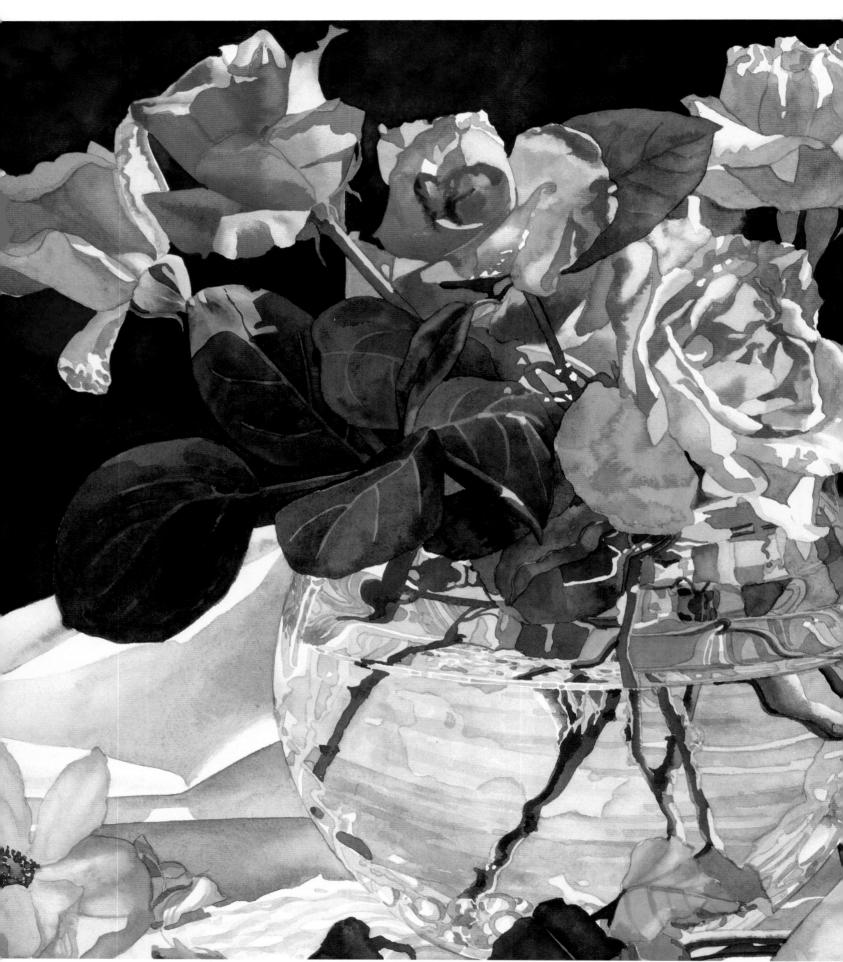

CRYSTAL REFLECTIONS WITH ROSES
Sharon Towle, watercolor on 180-lb. cold-pressed paper
22" × 30" (55.9cm × 76.2cm)

Turn On the Light

Any nose may ravage

with impunity a rose.

—Robert Browning

Photo Reference Helps Capture Quickly Moving Sunlight

MICHAEL GERRY

All my blossoms are sunlit to achieve the drama of value and color contrasts. For this reason I work only from slides, since they are usually much more accurate in color and light than photographic prints. Before the invention of photography, my work would have been very difficult. Since the sun on my blossoms moves far faster than I can capture it, a sketch just does not convey enough information in the short time I have to make it. **TECHNIQUE:** There are no secrets to my technique except maybe values, the importance of which beginners often grossly underestimate. I paint wet-into-wet on a light gray gesso ground (on rabbitskin glue on linen), which allows me to put whites down first. They appear more interesting when some gray shows through.

ROSES WITH DEW
Michael Gerry, oil on linen canvas
30" × 36" (76.2cm × 91.4cm)

Strong Side Light Reveals Texture

VIVIAN R. THIERFELDER

This typical spring bouquet of informally arranged tulips and freesia is lit strongly from the side. This creates prominent highlights and definite shadows, revealing shape and detail effectively. A liberal sprinkling of water on the flowers heightens the impression of freshness and immediacy. **TECHNIQUE:** These flowers were set against floral fabric close in color to their own. The purpose served was two-fold in that it broke up the background in an interesting way and also set up a subtle dialogue between the flatness of the stylized background flowers and the highly realistic three-dimensional treatment of the bouquet. Ultimately, though, one must return to the unequivocal two-dimensionality of the painted surface. I liken the concept to being on a mental Möbius strip.

FLOR TEMPRANO
Vivian R. Thierfelder, watercolor on hot-pressed paper
30" × 21" (76.2cm × 53.3cm)

Overcast Day Heightens Color Intensity

DOUGLAS P. MORGAN

I was at a landscape-painting workshop in Eugene, Oregon, where I completed a study of this scene, which I later expanded to this larger canvas in my studio. It was late in the afternoon on a partially overcast day. Without the blanching effect of bright sunlight, overcast days yield wonderful color saturation. I was inspired by the richness of the red roses along with the myriad of yellows, pinks and violets of the other flowers. The contrast of these colors against their warm and cool complements in the foliage was striking. Since the light was fading, I was forced to work rapidly, which helped to keep the painting fresh.

TECHNIQUE: Outdoors, I usually paint on gessoed 6" × 8" (15.2cm × 20.3cm) or 8" × 10" (20.3cm × 25.4cm) wood panels. I lay down the flower colors first to avoid muddying them when painting the surrounding foliage. Rendering beautiful flowers on canvas takes lots of practice, so my best advice is to get outdoors and paint!

THE WEISS GARDEN
Douglas P. Morgan, oil on Belgian linen canvas
16" × 20" (40.6cm × 50.8cm)

Painting Intense Color at High Noon

J. CHRIS MOREL

Painting plein air in natural light always creates interesting conditions. Having just completed a morning painting in the beautiful garden courtyard of my friend, Walt Gonske, I decided to start another and paint right into the middle of the day. The light at this time is typically less desirable, because of the way the shadows drop straight down. This scene, however, provided an intense view of saturated warms against cools. There was also beautiful reflective light bouncing up from the sun-baked ground, adding rich tones to the colors in the shadow areas. So I ignored the general prohibition against overhead light and painted this in midday, midsummer. **TECHNIQUE:** I used my portable French easel and canvas primed with white acrylic gesso. I underpainted the entire canvas with a thin wash of Burnt Sienna and Alizarin Crimson. The changing light was quickly moving the flowers into shadow. This forced me to rapidly block in the shapes, colors and values, before adding any details.

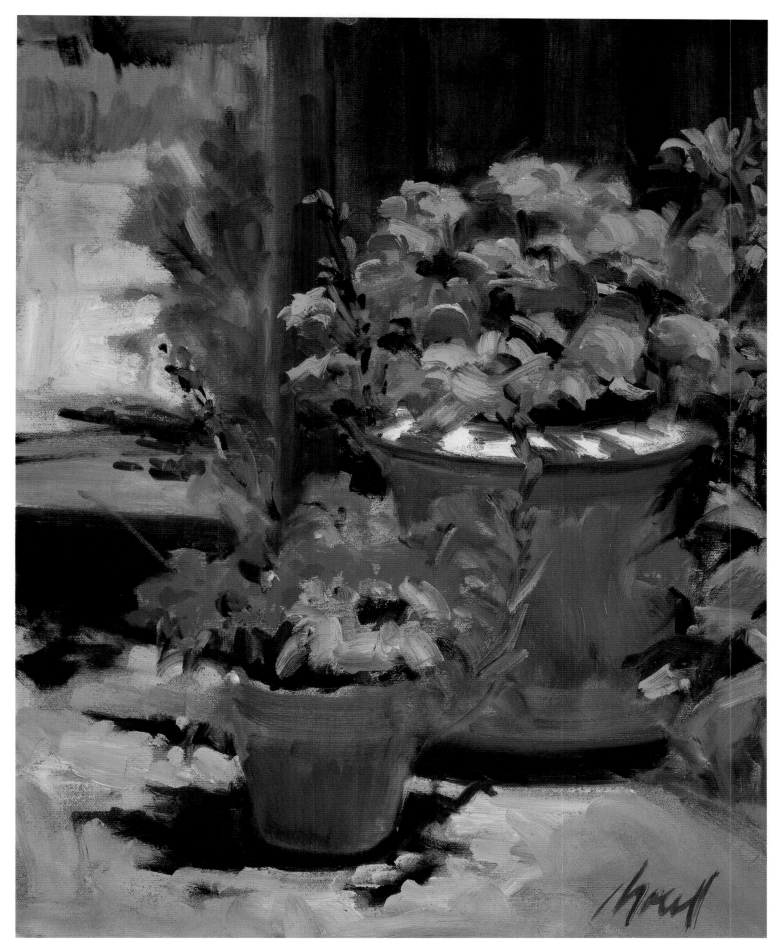

AFTERNOON FLOWERS
J. Chris Morel, oil on canvas
20" × 16" (50.8cm × 40.6cm)

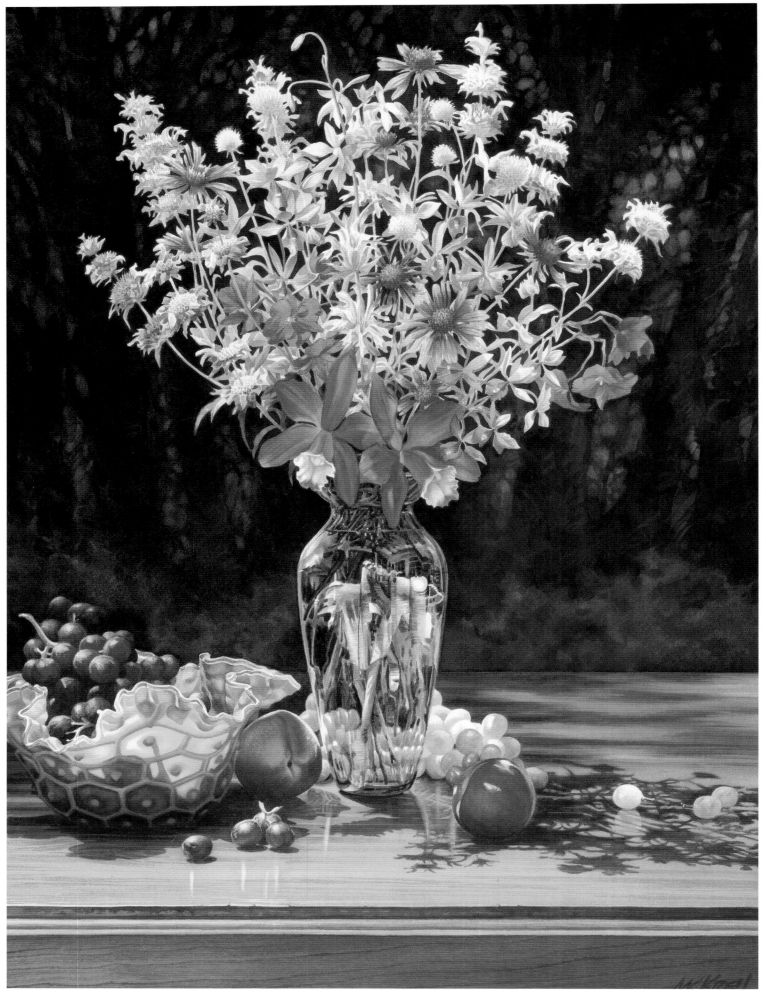

ORCHID SONG
Mary Kay Krell, watercolor on Arches 300-lb. cold-pressed paper
26" × 19" (66cm × 48.3cm)

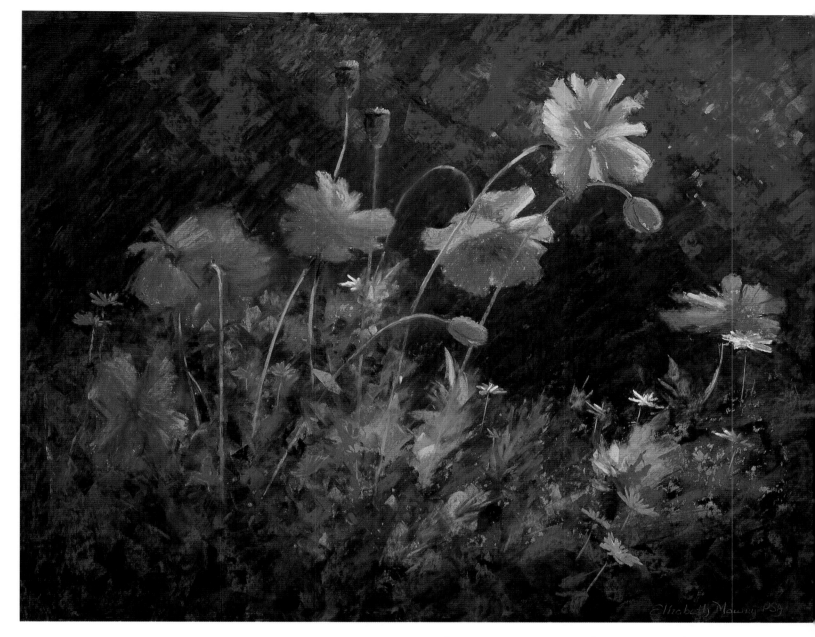

Light Pattern Enhances Rhythm

ELIZABETH MOWRY

The central idea behind this painting is the melodic rhythm of the tangled poppies. Almost all of the graceful flower stems are curved. The pattern of light values also moves in a circular direction to develop this idea. I do not attempt to copy nature, but instead try to capture its spiritual essence in my work. When I see something beautiful outdoors, I isolate what speaks to me, and then develop a composition to express that single idea.

TECHNIQUE: It was important in this painting to keep detail within the area of focus, and to relentlessly omit all other detracting specifics. The fine lines of the poppy stems make an interesting directional contrast to the loose sidestroke of the foreground foliage that loses all edge before it reaches the near bottom of the painting. Light is also kept within the focused area.

JOSIE'S POPPIES
Elizabeth Mowry, pastel on Ersta sanded pastel paper
18" × 24" (45.7cm × 61cm)

Brilliant Sunlight Demands Center Stage

MARY KAY KRELL

This still life was arranged in collaboration with a friend who grows orchids and nurtures native Texas plants. The arrangement includes three species of orchids and two species of wildflowers. My first impression was that the flowers presented an impossibly detailed challenge. But the Texas summer sun provided the needed catalyst to create, causing the arrangement to appear to glow from within. At one time, I would have balked at presenting flowers in such a straightforward manner. But the brilliant light and color precluded any compositional maneuverings; they demanded center stage. **TECHNIQUE:** I felt the flowers were in danger of being overpowered by the (then) intense colors in the background. To solve that dilemma, I darkened the background with four dark, rich washes over a clearly defined pattern of trees and dappled light patterns.

PEONIES
Barbara Newton, colored pencil
on Strathmore 500 Series bristol,
plate finish
19" × 15" (48.3cm × 38.1cm)

Delicate Colored Pencil Application for White

BARBARA NEWTON

Early one summer morning I was stopped midstride by the display of sunlight illuminating a vase of peonies. I attempted to portray the fragility of those first blooms of the year and how their plump softness played against the fractured, crisp sparkle of surrounding glass. The angle of the table leads the viewer into the scene. To keep the spotlight on the peonies and glass, I used a subdued dark background that allows the viewer to enjoy the "main event" without distraction. **TECHNIQUE:** Portraying sunlight on a light object is always a challenge with the translucent medium of colored pencil. White areas are bare paper requiring discriminating color application to create form. I used photos as reference for the fleeting morning sunlight and perishable flowers, but kept the plate, vase and votives in front of me as I worked. Strong lights and darks placed next to each other portray sparkling glass.

God is in

the details.

—MIES VAN DER ROHE

AMONG THE IRIS
Lisa Fields Fricker, oil on
linen canvas
30" × 24" (76.2cm × 61cm)

Backlighting Transforms Color and Form

LISA FIELDS FRICKER

This painting was commissioned by Kimberly's father. The family already owned my earlier portrait of her, so this time I was allowed freedom to design a garden setting and pose my beautiful young model at will! I had many, many ideas and did several sketches in order to settle on this composition. Fascinated by the magical colors of the light as it moved through and across the complex forms, I worked to strike a balance between areas of interest in the flowers and the figure.

TECHNIQUE: Starting with photos of my own iris in brilliant sunlight, I designed an imaginary garden that would sweep in an S-shape through the painting, tucking my model into the middle ground. These ideas were set down in a 6" × 8" (15.2cm × 20.3cm) oil compositional sketch for client approval. I then photographed Kimberly in similar light outdoors and worked from all these references, following my composition.

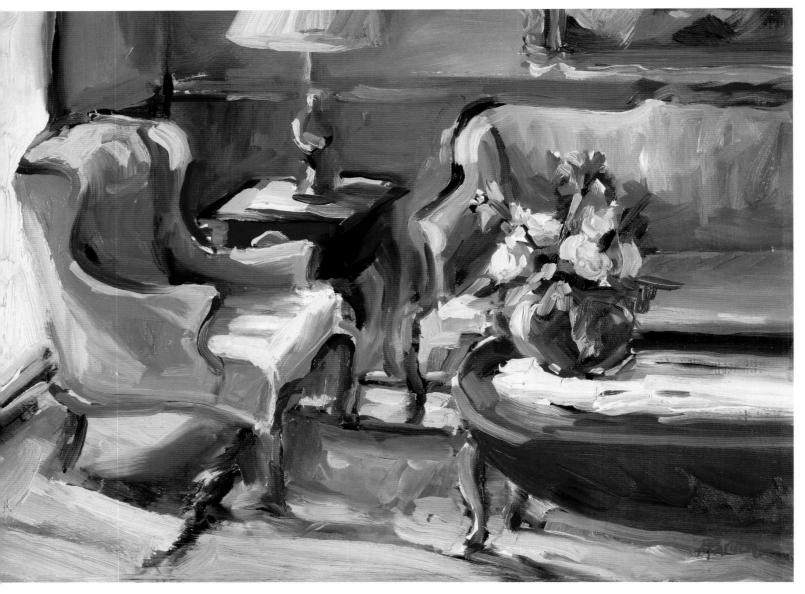

SWEET GENTLE LIGHT
Bonnie Paruch, oil on panel
9" × 12" (22.9cm × 30.5cm)

Light Transforms the Commonplace into the Extraordinary!

BONNIE PARUCH

This painting was done on a gray, damp winter day. My friend and I had planned on painting outdoors, so we were disappointed by the weather. I purchased a spring bouquet to lift our spirits and to create a centerpiece for a still life. After casually placing the flowers on a living room table, warm sunlight suddenly spilled into the room. The light and the flowers transformed the scene into a beautiful assembly of color and pattern. I envisioned a painting that could capture a moment of friendship and warmth. I set up my easel (on a tarp) and painted alla prima, working quickly to capture the natural light. **TECHNIQUE:** My painting method is based on a plein air approach. I try to keep it simple by using a limited palette, one or two bristle brushes and a very direct application of paint. To help me identify value correctly, I initially view the subject through a red photographic filter. To help me focus on large shapes (vs. little details, which can trip me up), I keep my glasses off. I make an effort to keep each stroke clean, each color fresh.

Outdoor Light Can Create a Ready-Made Composition

DOROTHY HRABACK

When weather permits, I paint outdoors. Locations are chosen for their interesting light and good composition. Often I use field sketches to work out larger pieces, which is the case in *Hinsdale Summer*. I had painted the scene on site (in a smaller scale), snapped photos and finished the large scale painting in my studio. **TECHNIQUE:** I work alla prima, wet-into-wet, all at once, not thoroughly mixing my colors to keep things fresh, thus avoiding muddy colors. The focal point contains the lightest lights, darkest darks, sharpest edges and oftentimes the brightest colors. I like to use Cadmium Orange, Cadmium Yellow Light, Cadmium Red Light, Permanent Rose, Transparent Oxide Red, Viridian and Alizarin Crimson. I avoid off-brands of paint and prefer hog filbert and flat brushes, with some round sables and a painting knife.

HINSDALE SUMMER
Dorothy Hraback, oil on linen canvas
36" × 48" (91.4cm × 122cm)

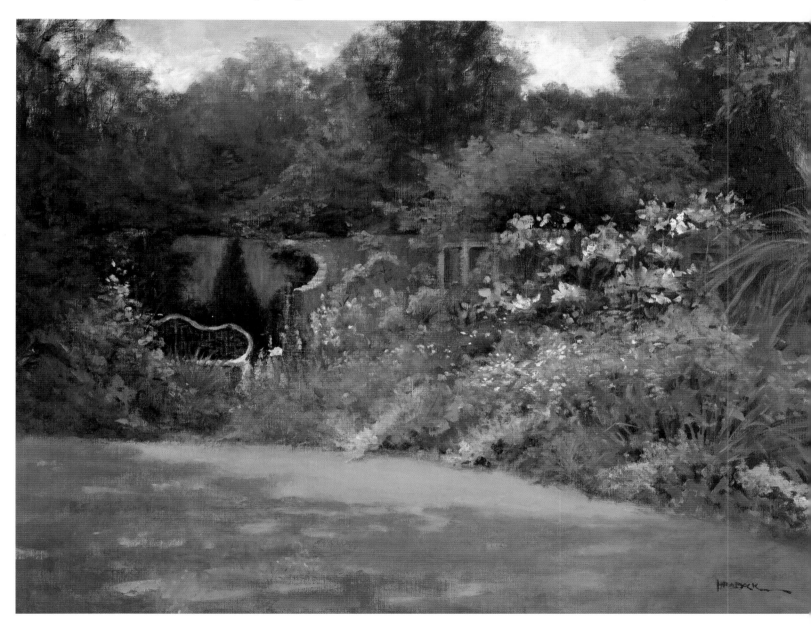

God created beauty and the

soul of man.

An artist's business is to

combine the two.

—ALAN WOLTON

Find the Rich Color in Shadows to Define the Sunlit Parts

M. LAUBHAN YANKE

Whatever the subject, the critical factor is light; light sets the mood, illuminates beauty. The sunlight streams through the east window as I put together this still life. After placing the sunflowers gathered from the roadside in my blue pitcher, I step back and try to see "it"—that special moment when all factors are in sync. This is when the inner perception happens, this is what I paint.

TECHNIQUE: Painting "light with color," as Robert Henri once said, is how you make the subject sparkle. As you view a flower in bright sunlight, you realize the richness of color in the shadow helps define the sunlit parts.

Airbrush Captures the Vivid California Sunshine

GARY H. WONG

While driving along the highway towards Antelope Valley, California, I was suddenly engulfed by the warmth and beauty of poppy flowers in bloom as far as my eyes could see. I spent hours walking through fields and meadows searching for the right flowers to inspire my painting. These colorful California state flowers were breathtaking, each one reaching and stretching toward the warm sunshine. **TECHNIQUE:** I captured the essence of these flowers from memory and photos taken while walking through the vast poppy fields. I sketched the details of the flowers against a blurred and subdued background to enhance my focal points. Next, I masked off the flowers, and then I airbrushed my painting to 90 percent completion. With the use of a fine-tipped watercolor brush, I detailed the accents to their final presentation.

CALIFORNIA SPRING
Gary H. Wong, airbrush color
on illustration board
11" X 15" (28cm X 38.1cm)

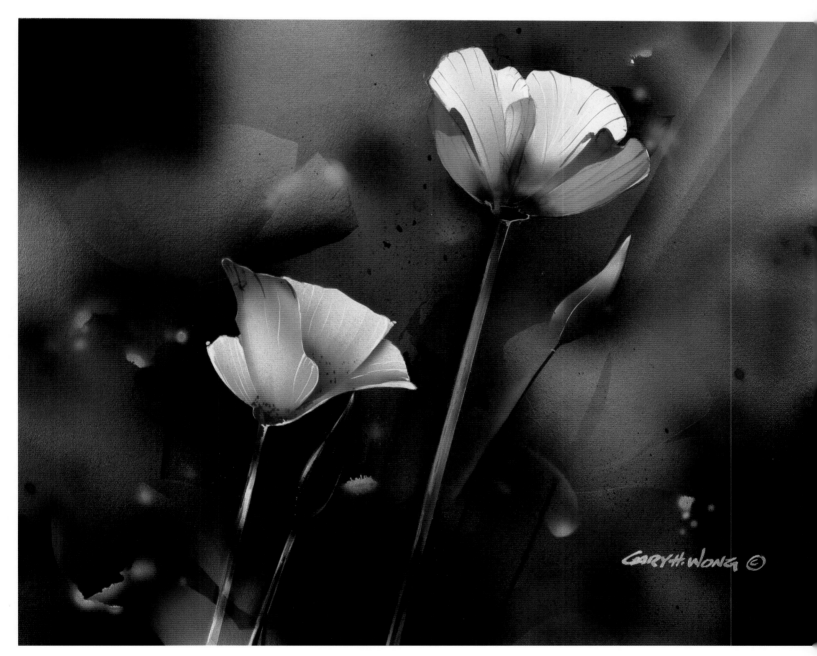

BAVARIAN SPRING
Olga J. Miniclier, pastel on museum board
primed with a gesso and pumice mixture
20" × 28" (50.8cm × 71.1cm)

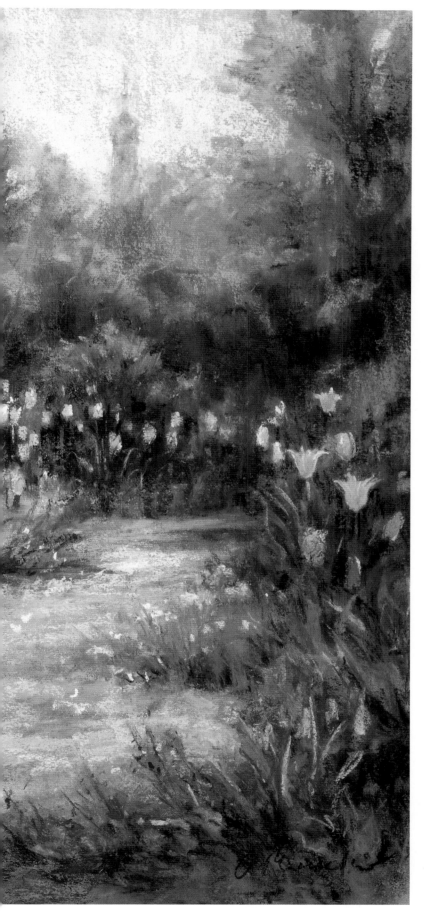

5

Convey Mood

He who plants a garden

plants happiness.

—Chinese Proverb

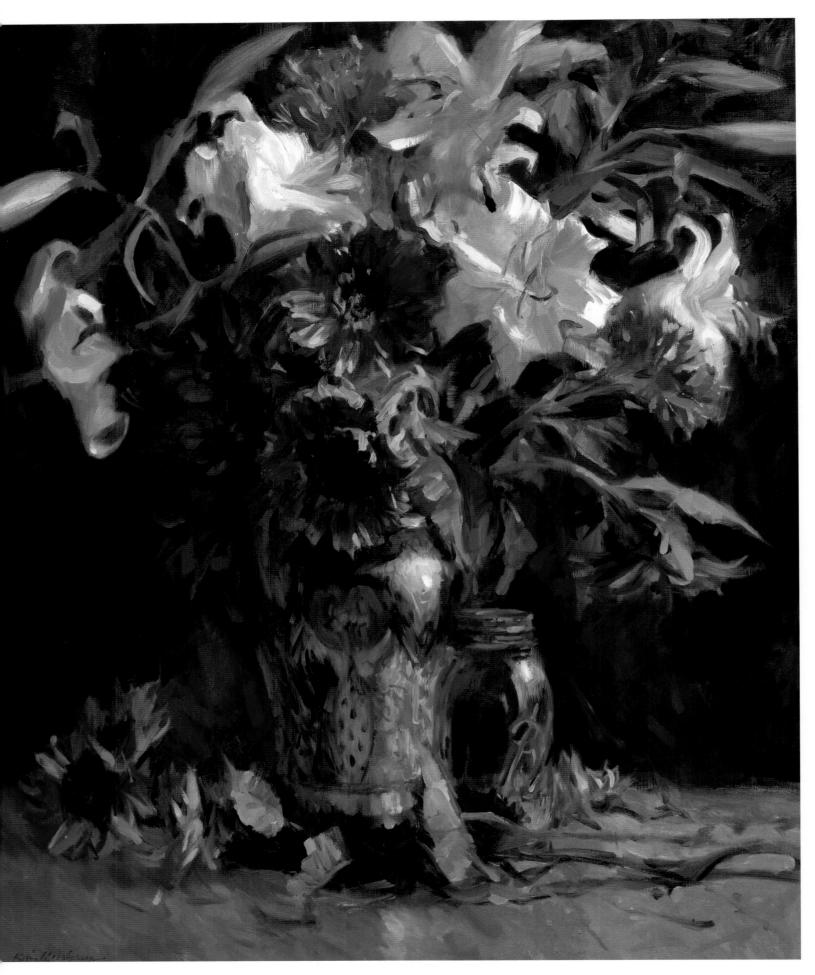

CASA BLANCAS AND RED SUNFLOWERS
Kevin D. Macpherson, oil on linen canvas
30" × 36" (76.2cm × 91.4cm)

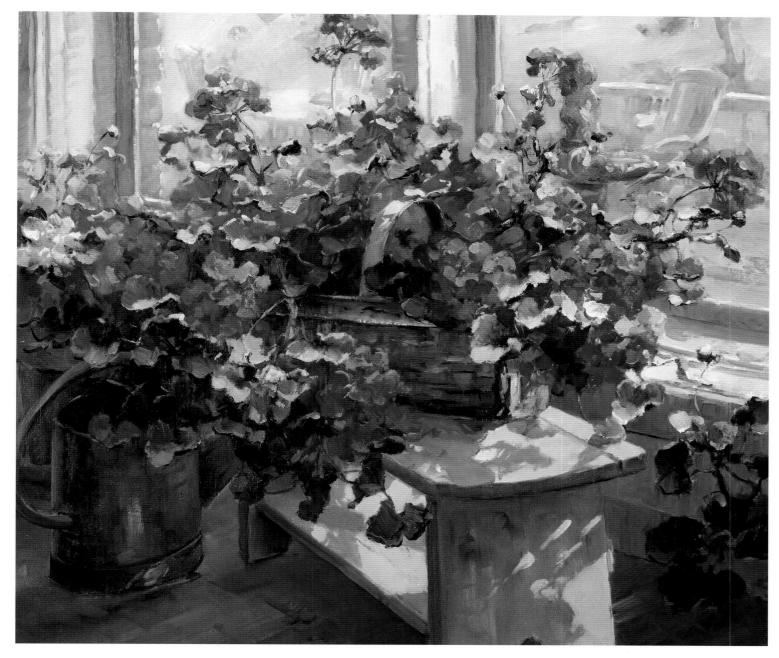

Work Quickly to Express Your Impression

KEVIN D. MACPHERSON

Sometimes a subject calls you to paint it. My wife, Wanda, entices me with bundles of fragrant flowers. She gets to enjoy the flowers and I get to paint. Fresh flowers have an immediacy that gets your juices flowing. **TECHNIQUE:** I painted this on Belgian linen using north light. I try to finish as much as possible in the first session. My first day of six to eight hours will accomplish 90 percent of the painting for a still life this large. Sometimes the last 10 percent can take a few more days. Working fast, I can better obtain my impression.

Paint Experiences That Awaken Inner Excitement

M. LAUBHAN YANKE

This was a moment in time. As I walked through the sunroom, there it was—an overflowing basket of red geraniums, the elements of light playing with shapes and colors. It was as if I was seeing it for the first time. That experience evoked a feeling, an inner perception that excited me. To put this into a painting, the light and shadow masses must create movement and rhythm, while the filtering of light within the masses (shown by subtle color changes) creates the nuances that read space or atmosphere. **TECHNIQUE:** Paint what you experience. The subject, style or medium is immaterial as long as the artist feels an inner excitement or connection with the painting. Be willing to experiment with your materials and allow yourself freedom of expression.

HOLD THIS MOMENT
M. Laubhan Yanke, oil on linen canvas
26" × 30" (66cm × 76.2cm)

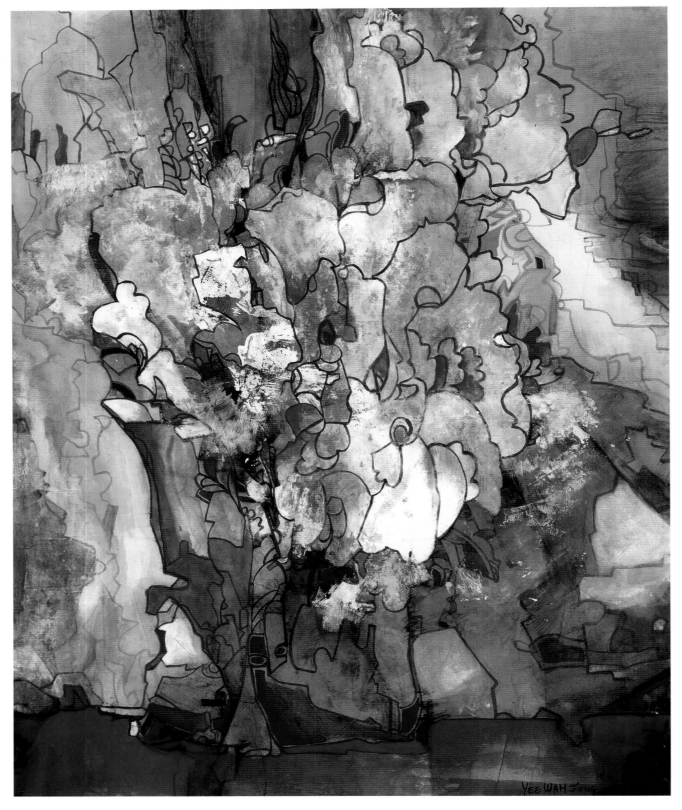

Paint a Memory and Let the Viewer Fill in the Details

YEE WAH JUNG

This painting was done from a picture of colors and lines molded into certain shapes. These shapes look like some kind of flowers at a distance. I like to leave plenty of room for the viewers to use their imaginations. **TECHNIQUE:** The painting was done with acrylic paints on rice paper. I used a bamboo brush to paint. There was no still life before me, nor did I paint on location. It was the work of association, imagination by choice of colors and shapes. The subject matter served as the source of inspiration only.

FOR A REFRESHING COMBINATION
Yee Wah Jung, acrylic on rice paper
21" × 17" (53.3cm × 43.2cm)

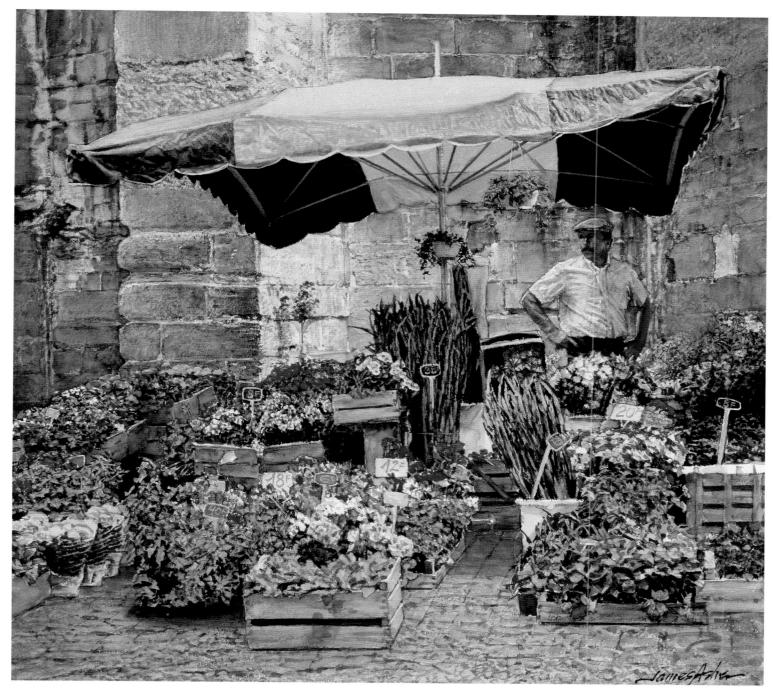

A Quiet Moment in Soft Light

JAMES ASHER

I visited L'isle Sur la Sorgue on a sunny Sunday morning in June. The village is in the south of France near Avignon. Sunday was market day and vendors were setting up food and clothing stalls throughout the village. This flower seller had come earlier than the rest and had arranged his cut flowers and bedding plants in anticipation of the day's commerce, so there was nothing left for him to do but wait. What attracted me was the soft morning light that had not yet found its way down into the narrow streets, the intensity of his colored umbrella against the weathered stones of the church apse, and the silent motionless waiting for the day to begin—all adding up to a fleeting quiet moment. **TECHNIQUE:** I have a great deal of respect for the traditional techniques in watercolor painting. Therefore, this painting was painted entirely in transparent watercolor without the use of white. I paint in "dry-brush" technique with the paper stretched on a drawing board and supported on a vertical easel. The biggest challenge of this piece was to capture the luminous color of the umbrella with a transparent medium.

Express Opulent Abundance

BARBARA EDIDIN

The title of this piece, *An Embarrassment of Roses*, is a take-off on the expression "an embarrassment of riches." I wanted to emphasize the feeling of abundance and opulence that I felt when I looked at that assembly of frowzy, heavy blossoms. My still life arrangements are not spontaneous, uncontrived groupings of flowers and objects; my subjects are very obviously posed. That's why I have referred to them as flower portraits. They often look to me as if they've just stepped out onto a stage. In the case of *An Embarrassment of Roses*, they look as if they were posing for a formal family portrait, or perhaps an opera company about to sing.

TECHNIQUE: I prefer using a paper with a very hard, smooth surface. This paper becomes saturated relatively quickly and will not accept more pencil. That allows me, during the final layers of color, to obliterate the paper texture without so much effort that I wear out my pencils and my fingers. This technique produces a very luxurious and deep visual surface.

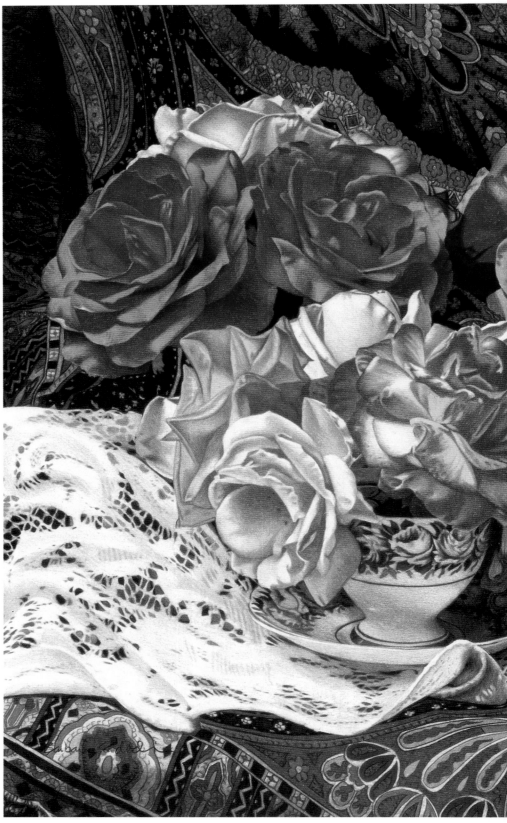

AN EMBARRASSMENT OF ROSES
Barbara Edidin, colored pencil on four-ply Strathmore 500 Series bristol, plate finish
18" × 30" (45.7cm × 76.2cm)

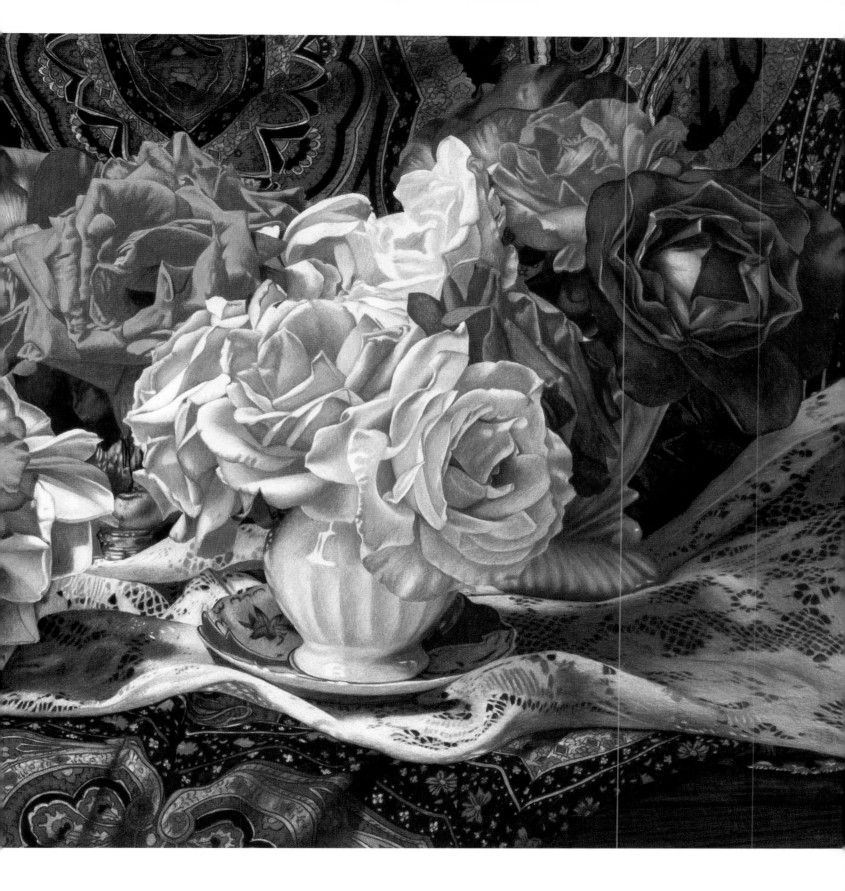

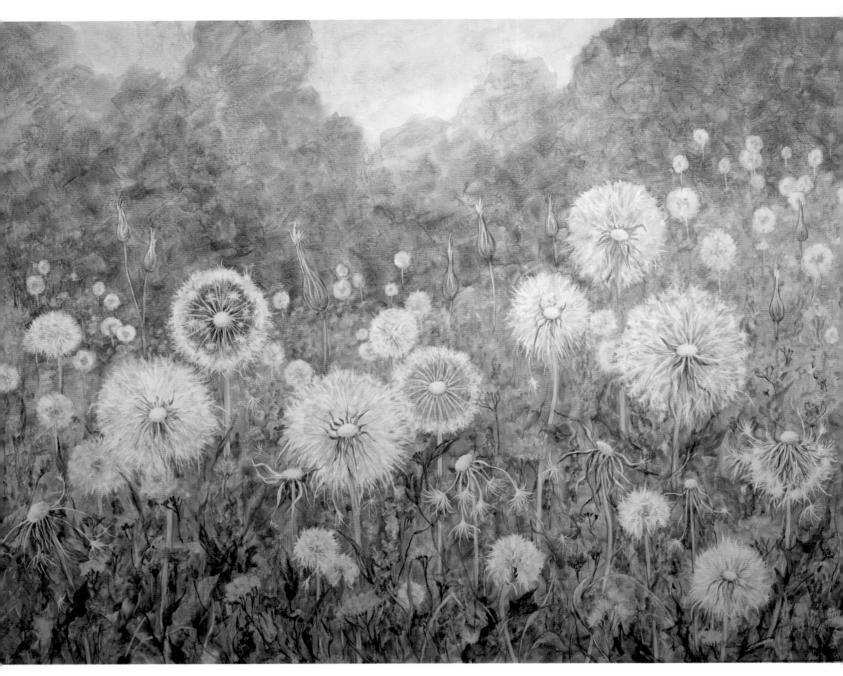

Subdue Contrast for an Ethereal Quality

JOANNE AUGUSTINE

On an island in Maine in early morning, I saw a hillside covered with enormous dandelions, their gray hairs shimmering in the sunlight. They were interspersed with lovely ferns, purple vetch and Indian paintbrush. That beautiful scene had an ethereal quality and stirred haunting memories of my childhood. My passion is painting flowers and my favorite weeds in all stages of their life cycles. I see them as a metaphor for our own lives, challenging us with their beauty and reminding us that we too are on borrowed time! **TECHNIQUE:** I like to use smooth surfaces and start with nonstaining pigments in the beginning until I am happy with the shapes. This allows me to make changes and pull out the lights and not use any masking for my whites. I don't mix in my palette, but prefer to let the colors intermingle and socialize with the water on the paper.

ISLAND DANDELIONS
Joanne Augustine, watercolor on four-ply museum board
26" × 34" (66cm × 86.4cm)

Their names I know not,

But every weed has

Its tender flower

—HAIKU BY SAMPU

A Mystical Light out of the Fog

CATHERINE ANDERSON

Traveling down the California coast, we stopped in Morrow Bay, a small fishing village on the ocean with a well-known huge rock. I woke up early and peeked out the door to see how the sun looked on the rock, only to see this breathtaking scene. Grabbing my camera from the motel room, I ran out in my pajamas, captivated by the white light shining on the daisies, through the heaviness and smell of the fog. **TECHNIQUE:** First, I masked out the daisies, stems, boats and tree holes along the coast. I then dove in with a 3-inch (7.5cm) wash brush with at least fifty washes of various colors. The masking came off in stages (i.e., the objects in the background were peeled off first, then more washes added). Next, the middle ground of masking was peeled off, and more washes were put on. The masking on the daisies was the last to come off, and then I worked on the flower details.

HARBOR FOG
Catherine Anderson, watercolor on
Lana 300-lb. hot-pressed paper
22" × 30" (55.9cm × 76.2cm)

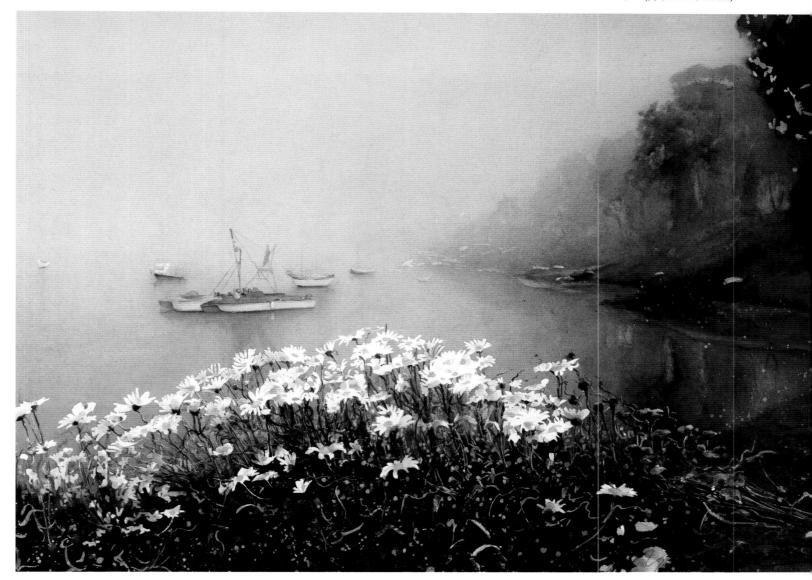

A flower more sacred than far-seen success

Perfumes my solitary path; I find

Sweet compensation in my humbleness,

And reap the harvest of a quiet mind.

—FROM THE POEM "TWOSCORE AND TEN" BY JOHN TOWNSEND TROWBRIDGE

CONVEY MOOD 73

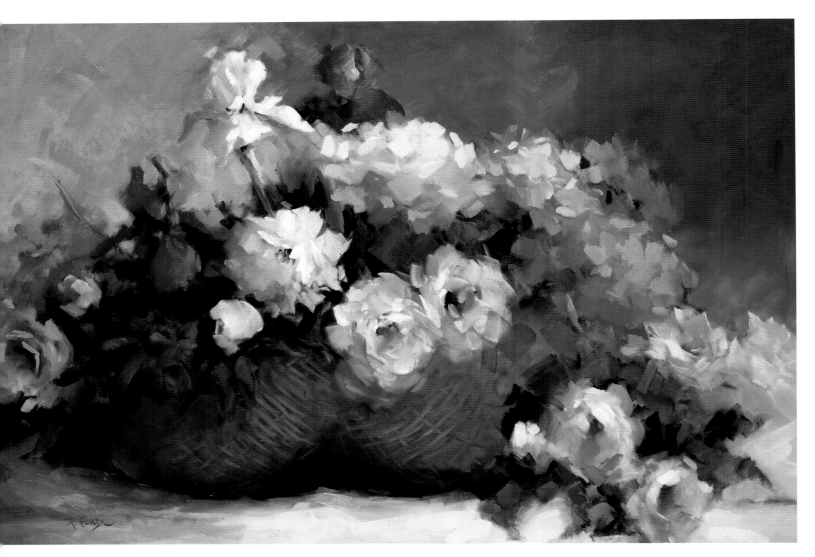

SYMPHONY
Pat Ford, oil on canvas
24" × 36" (61cm × 91.4cm)

A Soft Summer Symphony

PAT FORD

To me, the degree to which a painting achieves success equals the amount of my emotional involvement. This floral setup evoked an unusual amount of enthusiasm. The choice of early summer flowers represented a mood that begged for soft pastel colors. The flowers fascinated me with their color and size as well as the subtle changes of value and color in the translucent petals. *Symphony* was a spontaneous painting that took less than five hours to complete. **TECHNIQUE:** The initial lay-in was done using a turpentine and red-orange wipe-out technique. This provided a warm glow coming through the cool colors of the flowers. The grayed background helps the flowers to vibrate with vitality, as does the placement of warm against cool and bright against gray. All graying of color was done using complementary colors to maintain clean color.

If of thy mortal goods thou art bereft

And from thy slender store

Two loaves alone to thee are left

Sell one, and with the dole

Buy hyacinths to feed thy soul

—THE PERSIAN POET MULIH-UDDIN SADI

Photograph Your Subject in Bright Sunlight for Added Drama

JEANNINE M. SWARTZ

Romantic, nostalgic and dramatic best describe the feelings I try to express with my florals. I frequently incorporate props such as old lace, antique tea cups and crystal vases to achieve a romantic atmosphere. The high petal count of the peonies, along with the detail of the lace cloth, made this painting particularly challenging. Keeping the detail of the lace cloth to the foreground established a sense of depth. Since I wanted the flowers to dominate the composition, I painted them much larger than life-size. The dark, simple background helped to make the peonies stand out. **TECHNIQUE:** After carefully selecting and setting up an arrangement, I photograph the still life in bright sunlight. It is not unusual for me to use more than one roll of film on just one subject. The photographs are then enlarged and used to draw the final composition in detail. While I employ traditional transparent watercolor techniques, I prefer using liquid acrylics. Dark backgrounds add dramatic tonal contrast to my florals and liquid acrylics make it possible to paint these large areas of dark color.

PEONIES IN CRYSTAL
Jeannine M. Swartz, acrylic on cold-pressed paper
22" × 30" (55.9cm × 76.2cm)

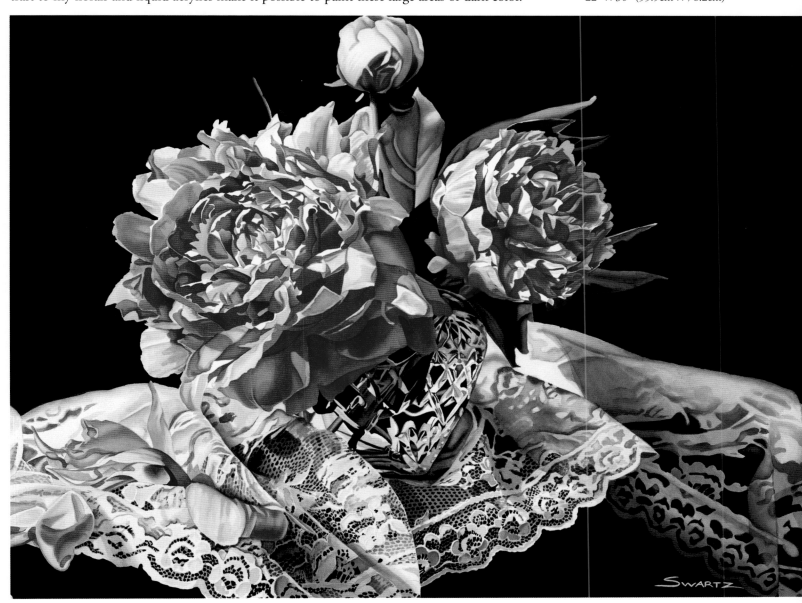

Recreate Ethereal and Spiritual Emotions in Your Studio

SUSANNA SPANN

Every morning the Florida sun pushes its way through the petals of my hibiscus flowers, projecting a dazzling glow of brilliant golds and royal crimsons. This ethereal translucence led me to set up a still life with three hibiscus and two crystal doves. By backlighting the yellow blossom, I got the same feeling of spirituality that I had first witnessed in the rays of the early morning sun. Certainly these delicate high-winged birds were guarding the gates of heaven, hence the name *Guards at the Gate*. **TECHNIQUE:** I used Arches 300-lb. watercolor paper and Winsor & Newton watercolor paints. The most difficult part of this painting was getting the yellows to "glow." I painted about twenty glazes over and over to get the intensity necessary to accomplish it. I used several colors of yellow, including Hansa Yellow, Lemon Yellow, Cadmium Yellow, Aureolin, Cadmium Yellow Pale, plus Rose Dore and Permanent Rose.

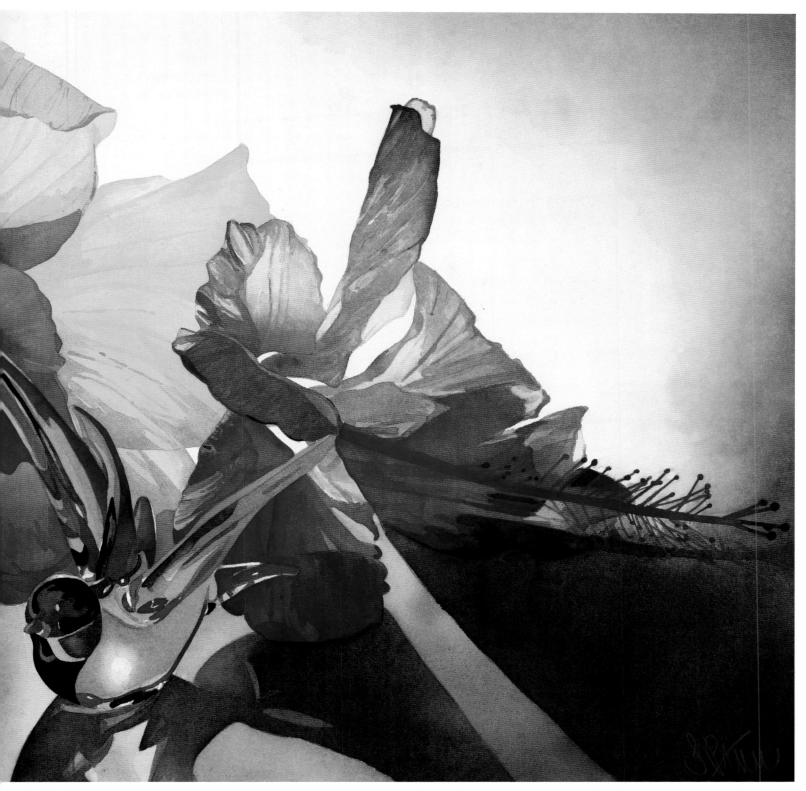

GUARDS AT THE GATE
Susanna Spann, watercolor on Arches
300-lb. paper
20" × 50" (53.3cm × 127cm)

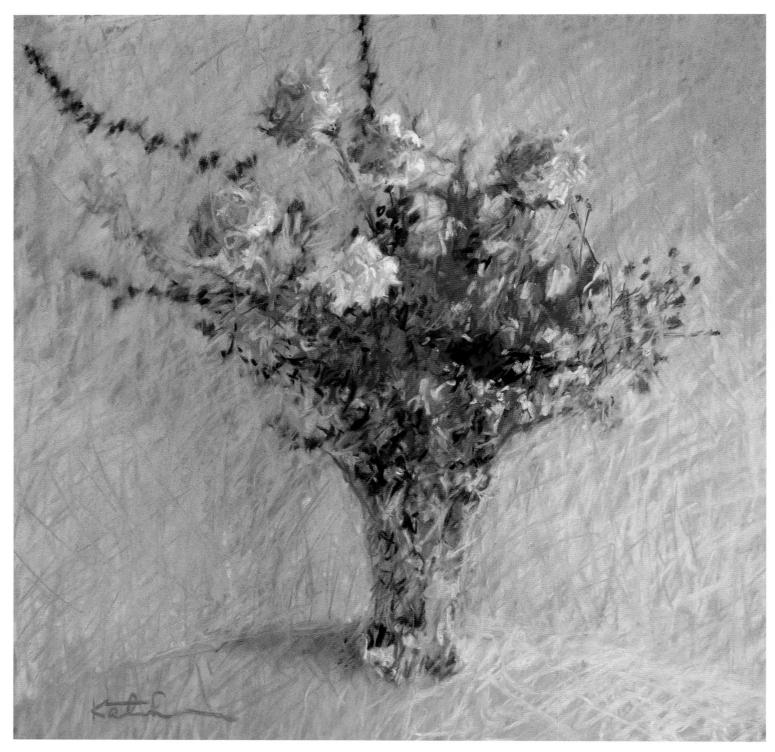

Paint an Impression Rather than Exact Form

CAROLE KATCHEN

My new friend, Alex, and his brother took me swimming at a swimming hole in the woods outside Hot Springs. During the day they picked a beautiful bunch of wildflowers for me, which I dried. It was a happy and romantic day. I decided to do a happy, romantic painting of the dried flowers.
TECHNIQUE: I put the wildflowers in a crystal vase, added a few dried roses and painted them with many quick, delicate strokes. The broken linear strokes work especially well for the cut glass surface of the vase. I was more concerned with giving an impression of the flowers than their exact forms.

MEMORIES OF LOVE
Carole Katchen, pastel
17" x 17" (43.2cm x 43.2cm)

It is at the edge of the petal that love waits.

—WILLIAM CARLOS WILLIAMS

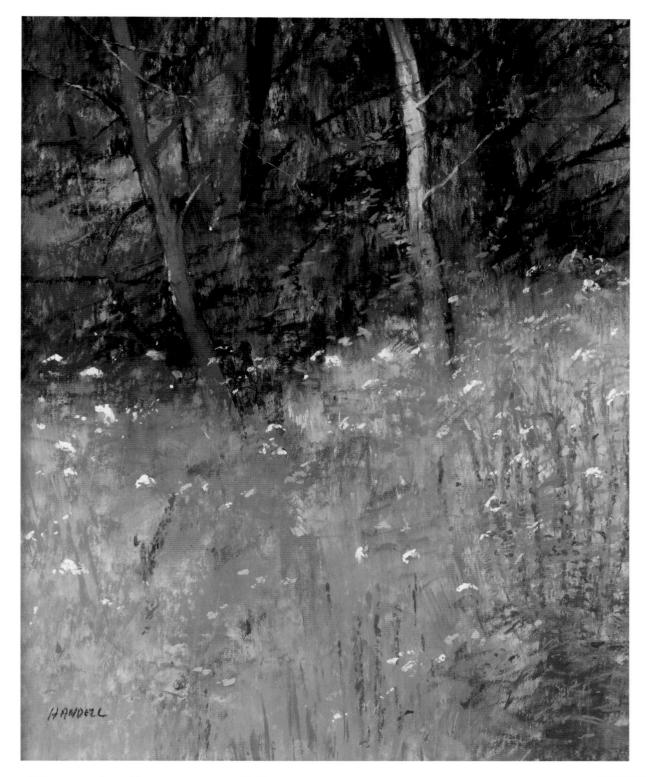

Show the Intensity of Summer

ALBERT HANDELL

SUMMER'S KALEIDOSCOPE
Albert Handell, pastel on
Kitty Wallis sanded pastel board
11" × 9" (28cm × 22.9cm)

This was painted in midsummer on Cape Ann. Wildflowers were abundant, and everything was alive, imparting a great sense of hilarity. The hilarity of the flowers was in the foreground, contrasting the darker background. Everything was alive—it was late July. The light was perfect, but time was short. I kept the image size small. The flowers were painted as colors, shapes and lost-and-found edges. I tried to avoid muddling the flowers. That would make them "too-heavy," taking some of the "life" out of them. **TECHNIQUE:** I kept the cool dark greens for the upper 40 percent of the composition; the warmer, lighter greens were reserved for the lower 60 percent. Then I very carefully "married" together the two contrasting areas with a rich green (midtone) that is painted in the foreground and the background. In the background this rich green indicates leaves and foliage, which draws your eye to them. By using this technique, contrasting areas flow together in harmony.

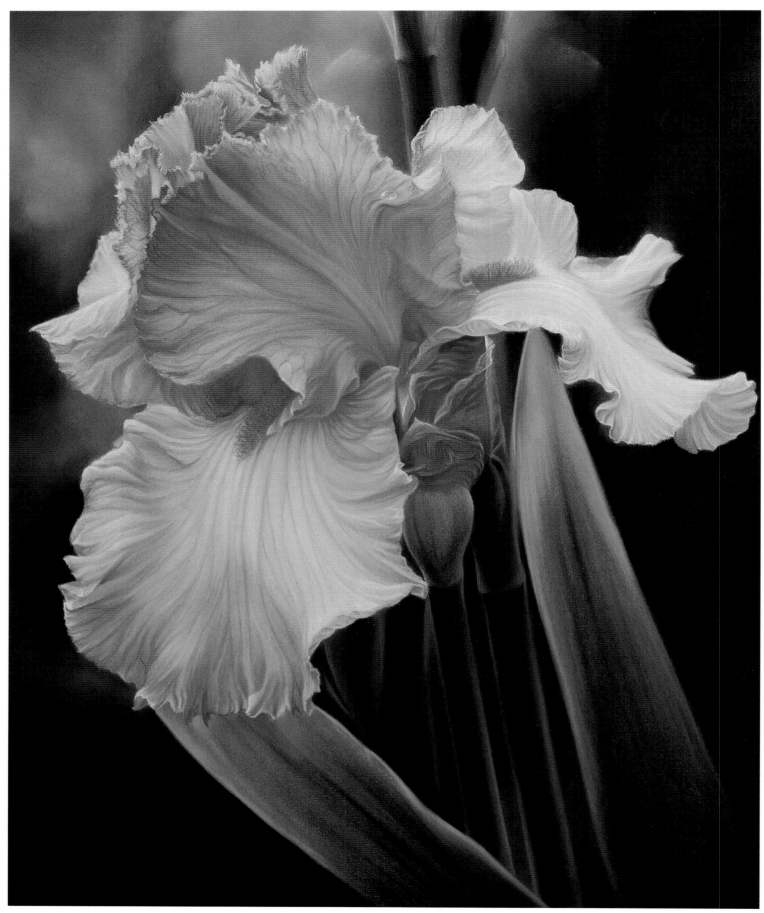

CALYPSO
Miciol Black, soft pastels on charcoal paper
20" × 16" (50.8cm × 40.6cm)

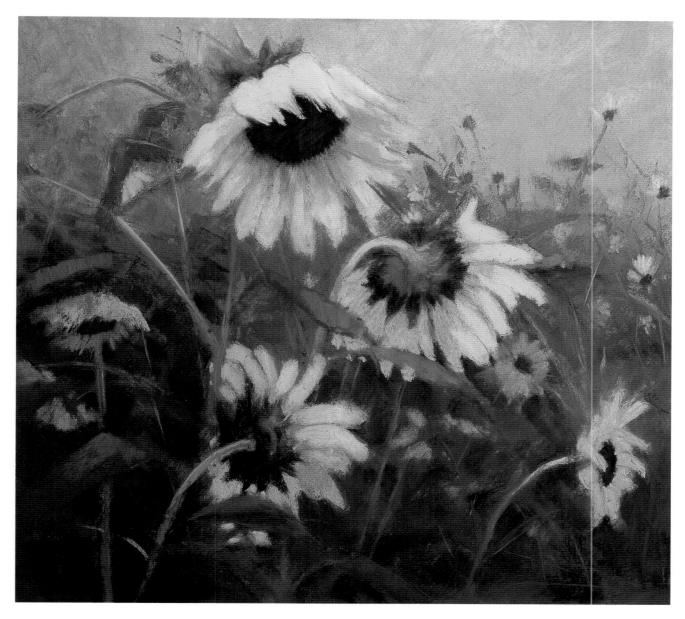

A Misty Morning, a Quiet Mood

ELIZABETH MOWRY

I prefer to paint flowers where they grow rather than in a vase. I think of such natural arrangements as "stilled life," a gift to those who will observe them. In this study of sunflowers, a quiet mood prevails. The dramatic shadows of strong sunlight are absent. Instead, I was touched by the humble existence of a few flowers at a nearby farm where they are grown for cutting. The misty early morning is suggested by the complementary pale violet background. Here, the usually showy sunflowers are not groping for attention from the viewer. They simply are. **TECHNIQUE:** Soft and lost edges portray a nonassertive mood in the painting. Even the backs of the flowers appear to yield to the mood of unpretentiousness. The painting was done with all soft pastels on a surface which encourages a soft line. I have found that a quiet mood is often easier to create on a day that is not sunny.

HURLEY SUNFLOWERS
Elizabeth Mowry, pastel on La Carte paper
15" × 16" (38.1cm × 40.6cm)

Capturing the Seductive Grace of a Symbol of Peace and Tranquility

MICIOL BLACK

The wondrous beauty in a single flower petal is infinite. Irises, the symbol of peace and tranquility, are a special love of mine. The most challenging aspect of *Calypso* was the minute detail of the ruffled edges of the uprights and falls. I saw a ballerina in this flower; I saw her bowing after her performance. The falls were the ruffled folds of her chiffon gown. I see this sort of analogous beauty in every flower I paint. At first, I'm entranced by their beauty, but then I wonder if I can capture what I see and feel. Like the soul of an angel, I want the flower to live forever.
TECHNIQUE: I used 100 percent rag charcoal paper in a neutral gray, a good variety and range of greens for backgrounds and a good range of all colors for the flower. No special techniques other than blending and smoothing—the right amount in the right place. A little more in the background, a little less in the foreground, and know when to avoid blending.

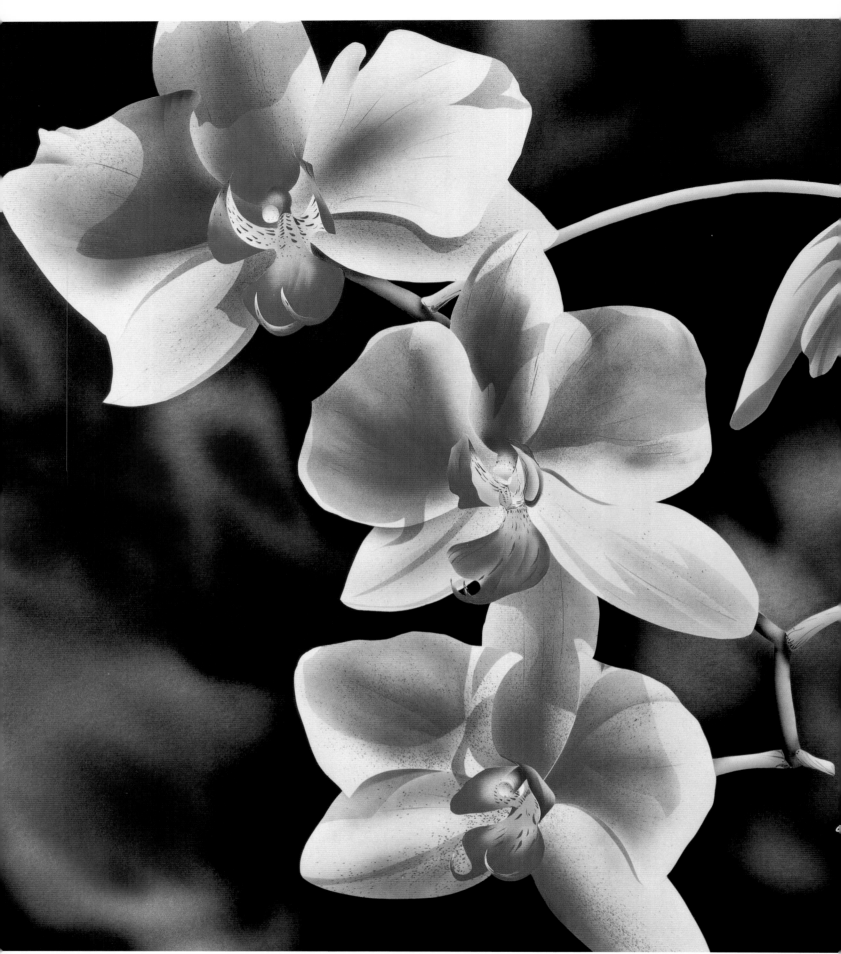

LAVENDER IN BLOOM
Gary H. Wong, airbrush color on illustration board
30" × 40" (76.2cm × 101.6cm)

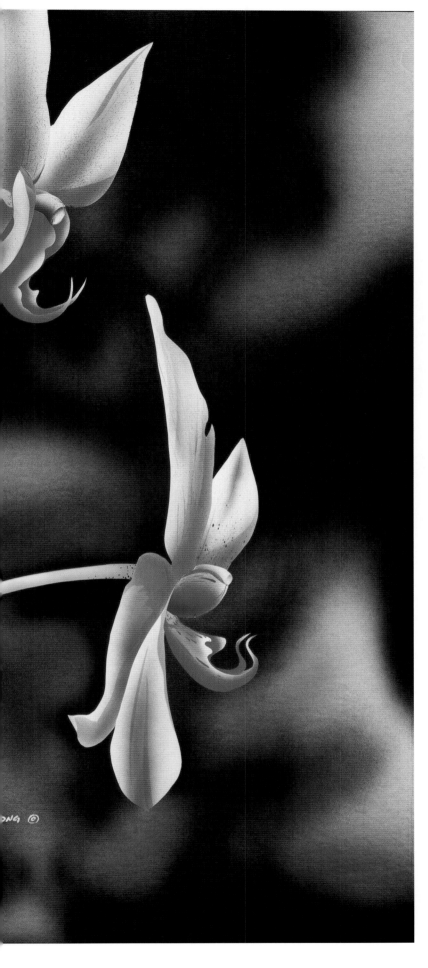

Highlight a Special Subject or Background

To create a little flower is the

labour of the ages.

—WILLIAM BLAKE

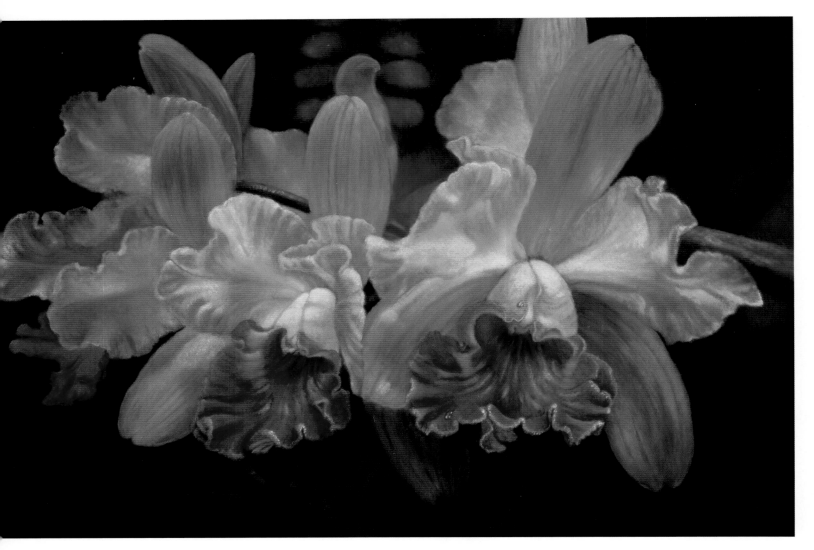

The Glory of Light

CAROLYN RAISIG

CATTLEYA ORCHID
Carolyn Raisig, oil on linen canvas
20" × 30" (50.8cm × 76.2cm)

My love affair with orchids began in Hawaii a few years ago. Their flamboyant blooms of such incredible richness and variety commanded my full attention for a whole week. Out of all the hundreds of photos I returned with, I chose this cattleya orchid to paint first. It seemed such a challenge to capture the aristocratic, deep-red, velvety texture and the surrounding ruffles of the "lip," in such sharp contrast to the iridescent golden sepals and petals. **TECHNIQUE:** Even though my flower subjects are varied, my technique is not. Starting with my own photographs, I decide which ones show the flower at its best, and I check how the shadows and lights interplay with each other. I start the painting by doing a detailed sketch using colored pencils, then start glazing in deep blue-violet, loose at first with linseed oil and then continuing with more glazes, getting tighter with detail. I work from dark to light, keeping highlights bright and the shadows cool. This method is the "Old World Renaissance" style of painting.

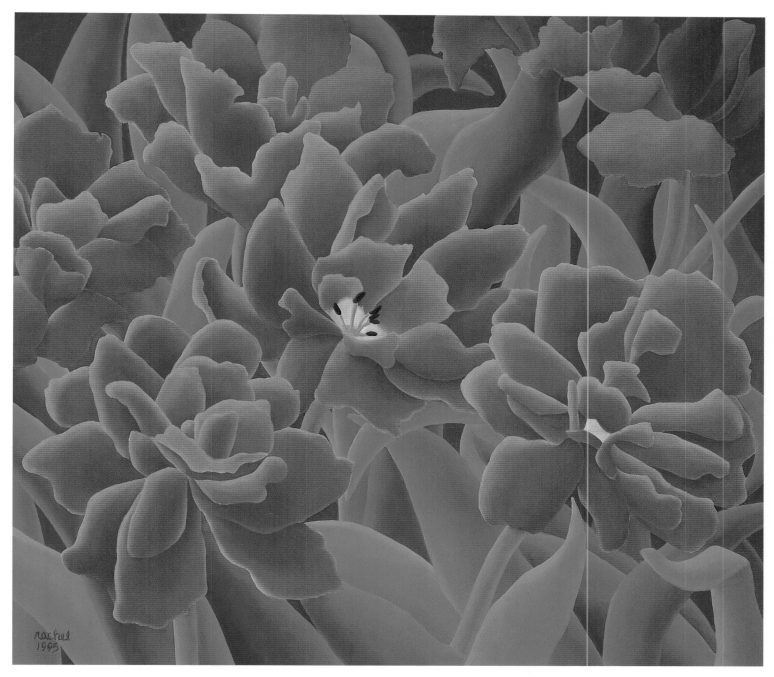

RED PARROT TULIPS
Rachel Crawford Imlah,
oil on linen canvas
18" × 20" (45.7cm × 50.8cm)

Lush Flowers Were Astonishing After Arabian Desert

RACHEL CRAWFORD IMLAH

Living several years in the deserts of the Middle East dimmed my memory of past visual palettes and provided a fresh surface for those sights yet to come. In this state of mind, I stepped into the magic of The Netherlands at the height of its tulip season. The colors, the unfolding of the petals, the bend of the leaves, and the layers-upon-layers of tulips dizzied me. I began photographing up close, knowing from the first click of the shutter that I had found something that would occupy years of my life. I had previously painted mostly people, but this compelling beauty set me on a "botanical" path I never before imagined. I began a series of 150 oil paintings of flowers in the style pictured here that I call *The Sensual Garden*. The series is still in progress. **TECHNIQUE:** The three-dimensional effect of these floral paintings is created by working from two directions at once—from the depths of the foliage to the tops of the petals, as well as from the background to the foreground. All edges are kept crisp but especially razor sharp at the foremost focus. Brushstrokes are eliminated so that the eye is not distracted from the impact of the images. To accomplish this soft blending I use only sable watercolor brushes, layer upon layer, an exacting technique.

Pansies: A Flower of Unique Color

ALEXANDER D. SELYTIN

The brilliant colors found in pansies have always inspired me. Since immigrating to the United States from the former USSR, I have especially enjoyed the variety of colors in nature—particularly in pansies. **TECHNIQUE:** I paint in a very traditional way—never using photographs. I paint what I see before me and add fresh flowers when needed. This allows the painting to continue to develop for several days or even weeks. If I painted from a photo that captured only a split second of the flower's existence, I would not have the life and freshness I hope to achieve in my work. Likewise, I never sketch the composition, but let the painting continue to unfold before my eyes.

PANSY POTPOURRI
Alexander D. Selytin,
oil on linen canvas
18" × 14" (45.7cm × 35.6cm)

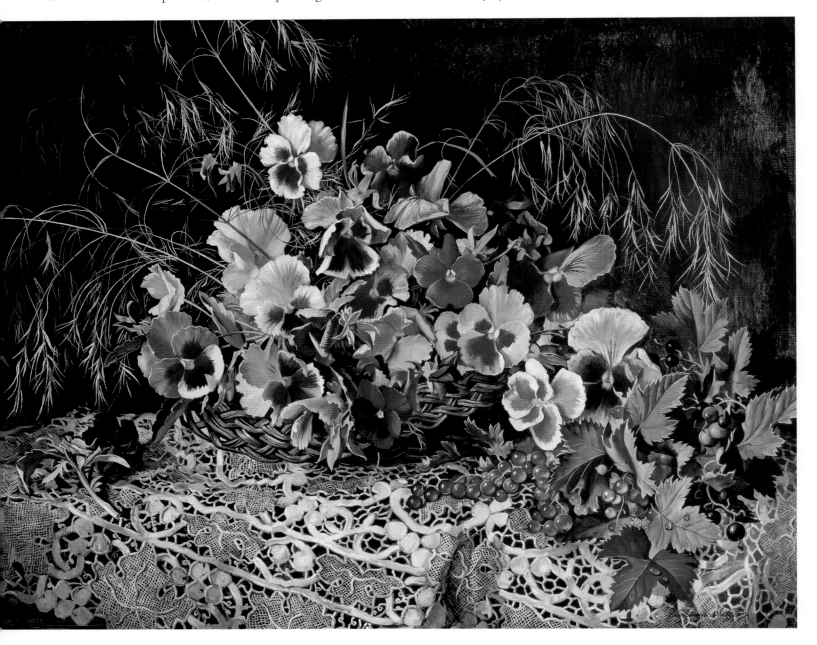

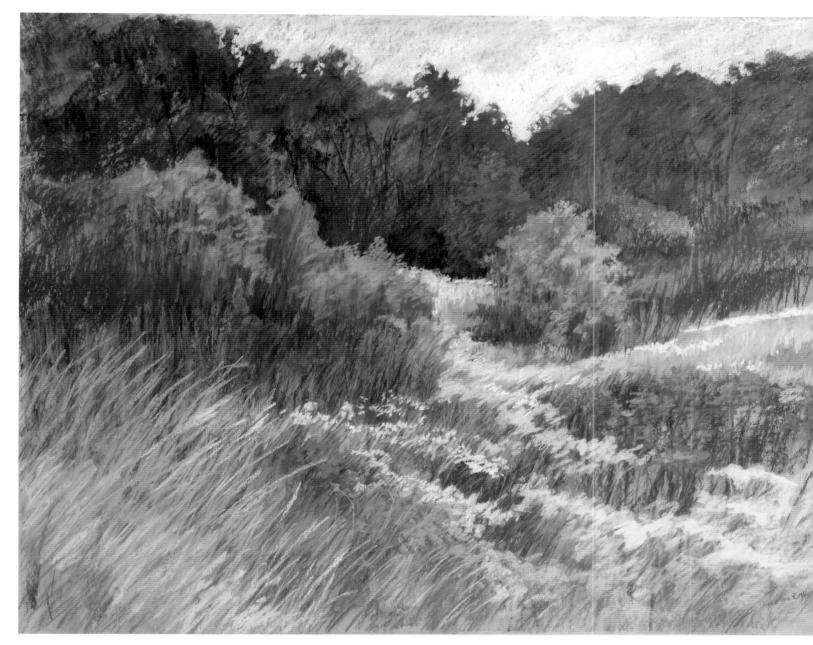

FIELD OF WILDFLOWERS I
Junko Ono Rothwell, pastel on
German Ersta sanded pastel paper
21" × 27" (53.3cm × 68.6cm)

Paint Wildflowers as Waves of Color

JUNKO ONO ROTHWELL

This was painted on location at the end of summer. I was standing in a marsh. It was hot, but I enjoyed painting there. I was at one with nature, and I was seeing and hearing the butterflies, dragonflies and cicadas. Wildflowers have beautiful colors in waves: yellow, purple, white. They show the rhythms of the breeze as waves show the rhythm of the sea. **TECHNIQUE:** I do a complete underpainting with pastel combined with turpentine. After that dries, pastels are applied again. I allow my strokes to show and indicate the direction of the plant growth.

Look, the winter is past,

the rain is over and gone.

The flowers appear on the ground,

the time of singing has come . . .

—BONNIE PARUCH

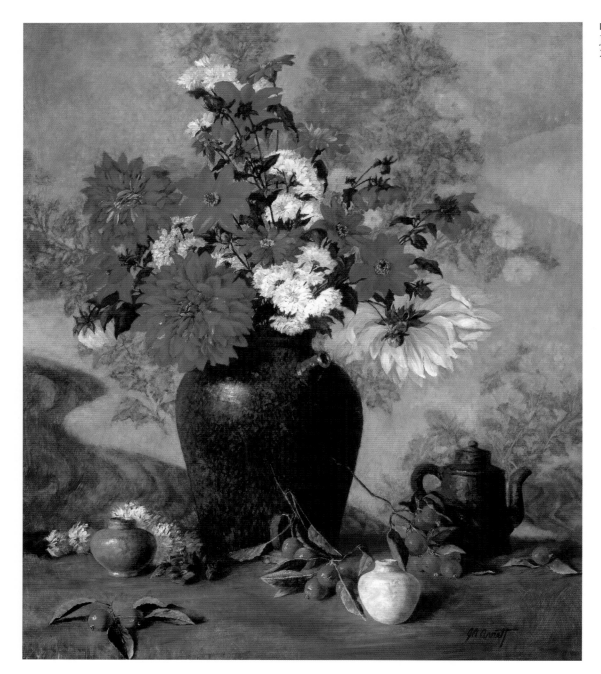

DAHLIAS AND GOLDEN SCREEN
Joe Anna Arnett, oil on linen canvas
26" × 22" (66cm × 55.9cm)

Create Two- and Three-Dimensional Forms

JOE ANNA ARNETT

I created this painting to challenge my ideas about how to create convincing two- and three-dimensional space in the same picture plane. All of the choices of colors and subjects were made with this problem in mind. The flat print of an Oriental screen in the background depicts both white and red flowers. The live flowers in the Chinese jar are also red and white, as are many of the other foreground objects. The fun of this painting was to continually make the foreground objects stronger to dominate the still strong colors and forms of the background. It was a constant push-pull to achieve the final result. **TECHNIQUE:** Impasto, or thick paint, is one of the greatest advantages of painting in oil. The flowers and other foreground objects were painted with thick, rich paint. To keep the screen in the background, I used thin paint and softened the edges of all the details of the screen. I also kept the values of the design on the screen close together while emphasizing the contrast of values of the objects in the foreground plane.

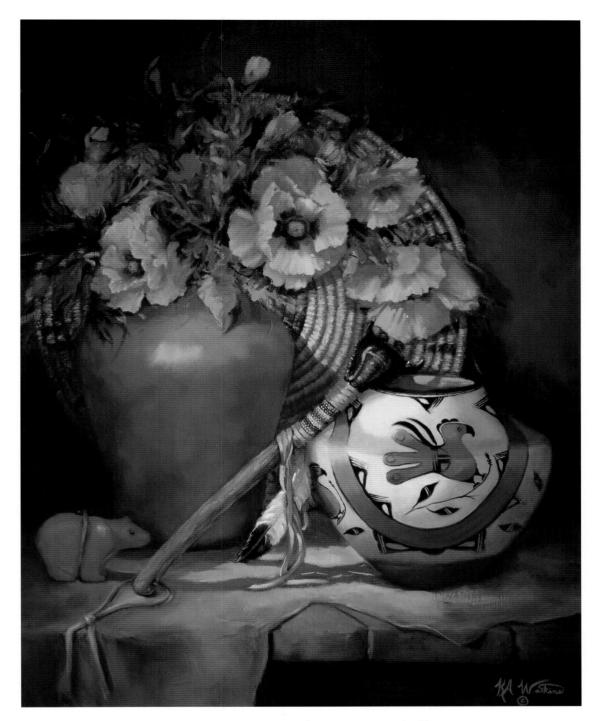

Large Poppies Inspire Southwestern Theme

KATHLEEN WATKINS

On a recent trip I took to Santa Fe, I was captivated by the magnificent, colorful poppies growing there. They were so bright, transparent and paper-thin they looked like crepe paper—totally unreal. I took many photographs for my library. In my studio I set up a few of my favorite southwestern collectibles, got out my photos and placed some silk poppies in the copper vase so I could see how the spotlight affected their form. **TECHNIQUE:** Working alla prima, I thinly sketched in the composition over an oil-toned canvas. I like to paint wet-into-wet, so I use a double oil-primed linen canvas (portrait quality) and mongoose brushes, with turpenoid natural as a medium. This combination lets me work wet-into-wet for a very long time. The paint stays put from the beginning with these materials, and I love working on the smooth canvas.

SANTA FE POPPIES
Kathleen Watkins, oil on linen canvas
28" × 22" (71.1cm × 55.9cm)

Try an "Angle Shader" Brush

LORETTA NORTH

This oak barrel planter had flowers growing from the holes cut in its side. I loved the contrast of the colorful flowers against the old stained wood. Part of my "critter" series, this painting has five insects and a shrew camouflaged in it as in nature. **TECHNIQUE:** My favorite brush is an angle shader. They are like flat brushes, but the end is cut at an angle. You can use the whole brush for doing larger areas, and with the tip you can get the tiniest detail.

THE OAK BARREL
Loretta North, watercolor on
Arches 300-lb. paper
28" X 21" (71.1cm X 53.3cm)

Flower Subject Melts into Background for a Patterned Effect

JOYCE PIKE

My idea here was to depict an overall patterned effect, reminiscent of antiquity as well as the delicacy of embroidery and fringe. I developed a pattern in the background that to some extent replicates the pattern that the flowers make. The delicate carving on the plant stand is subtle, not to overpower the overall pattern. In most florals the flowers dominate, but in this painting they are woven into the fabric of the whole painting. **TECHNIQUE:** I try to always have an idea or goal in mind before starting to arrange my setup; good composition begins with your setup. A good floral painting starts with what you see, then sifts through your brain and comes out your arm onto the canvas.

THE ORIENTAL PLANTSTAND
Joyce Pike, oil
40" X 30" (101.6cm X 76.2cm)

"Sun" Shines on a Special Antique Bowl

MARLA EDMISTON

The inspiration for this painting was the unique antique punch bowl with its intricate blue pattern and scalloped edges. To contrast its formality and to add a complementary color, I chose large, showy sunflowers. I wanted them to portray a radiant canopy of sunlight. I placed them to overhang the bowl so the reflected light would warm the inside of the bowl. The white table linens illuminate the entire area. Keeping the background simple and dark allows all the attention to focus on the beauty of the objects. **TECHNIQUE:** I begin by applying a medium-tone oil and turpentine wash to the surface of a gessoed wood panel. Every painting subject is set up in my studio and properly lit before painting begins. Most objects are painted close to actual size. Cut flowers require speed and accuracy, so brushwork is deliberate and precise in order to keep colors fresh and edges clean.

How to Paint a "Still Life" When Part of It Is "Still Alive"

KEVIN D. MACPHERSON

I wanted to paint a still life that included my kitty. I couldn't imagine painting a still life from photos, but painting my kitty from life would be a major challenge. He will sleep all day, but start to paint him and he is off. So I prepared sketches of Kitty and also created a three-dimensional soft sculpture out of cloth and tape to emulate the forms. I proceeded to paint the setup in north light from life. The relaxed forms of the tulips empathize with the sleeping cat.

TECHNIQUE: I painted on Belgian linen. Alla prima (wet-into-wet) works best for me; I can manipulate the wet paint to adjust shapes and edges.

A Quick Switch to a Dark Background

JEAN UHL SPICER

In designing flower groupings, I usually rely on carefully planned white negative shapes as backgrounds to offset the colorful shapes. A funny thing happened near the finish of this piece. I had painted all subject matter and was reviewing it for conclusion. I did a complete turn and decided to establish a rich dark background to project the flowers even further. It's wonderful to have this option, proving that first plans may not always be the best. **TECHNIQUE:** I had to carefully mask the painted leaves and outer edges of each flower. Turning the painting upside down, I poured six color glazes over the background to build the value and set the focal point. The use of transparent pigments on the flowers enable me to glaze, thereby achieving the luminosity that flowers require. Necessary pigments include: Aureolin, Permanent Rose, Permanent Magenta, Cobalt and French Ultramarine Blue.

FAMILIAR FRIENDS
Jean Uhl Spicer, watercolor on cold-pressed paper
18" × 24" (45.7cm × 61cm)

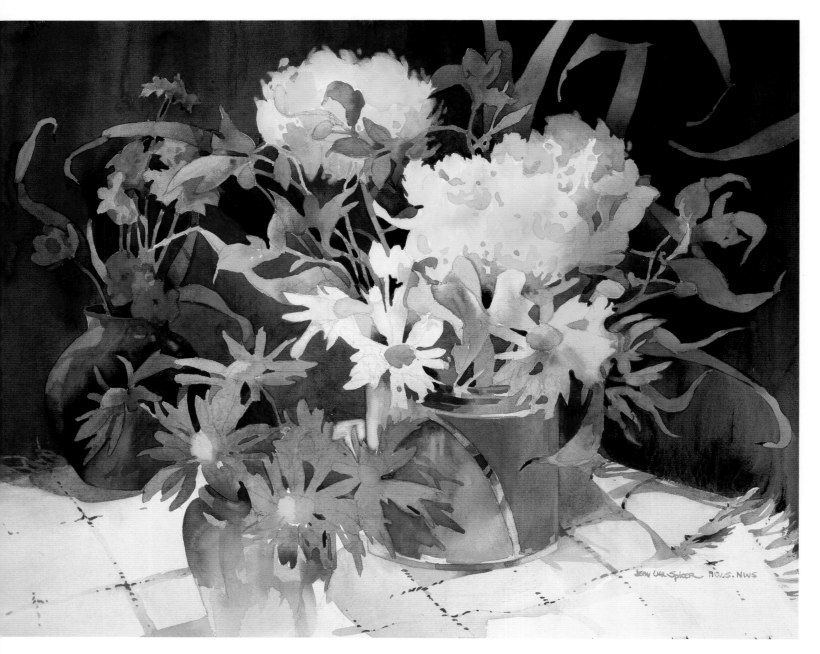

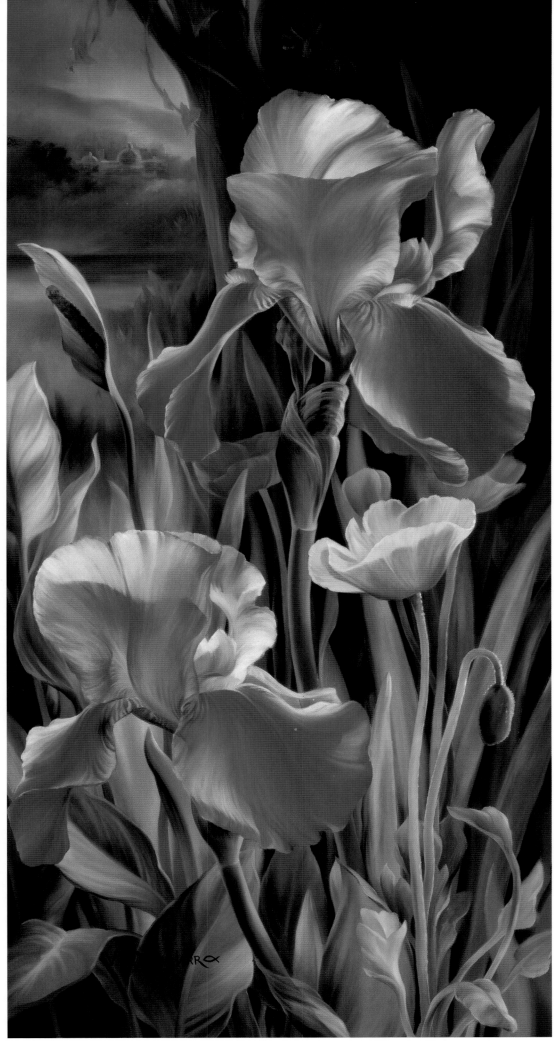

Create a Lush Composition Inspired by Many Photographs

VIE DUNN-HARR

When developing a floral I usually find inspiration by working from as many as thirty photographs at a time. I enjoy searching through photos I have taken over the years and selecting individual elements for a lush composition such as this. **TECHNIQUE:** The colors and shapes were altered as needed for the design. Creating the patterns of light was challenging and exciting to me, and they are essential to the design of the painting.

BLUE IRISES
Vie Dunn-Harr, oil on canvas
30" × 15" (76.2cm × 38.1cm)

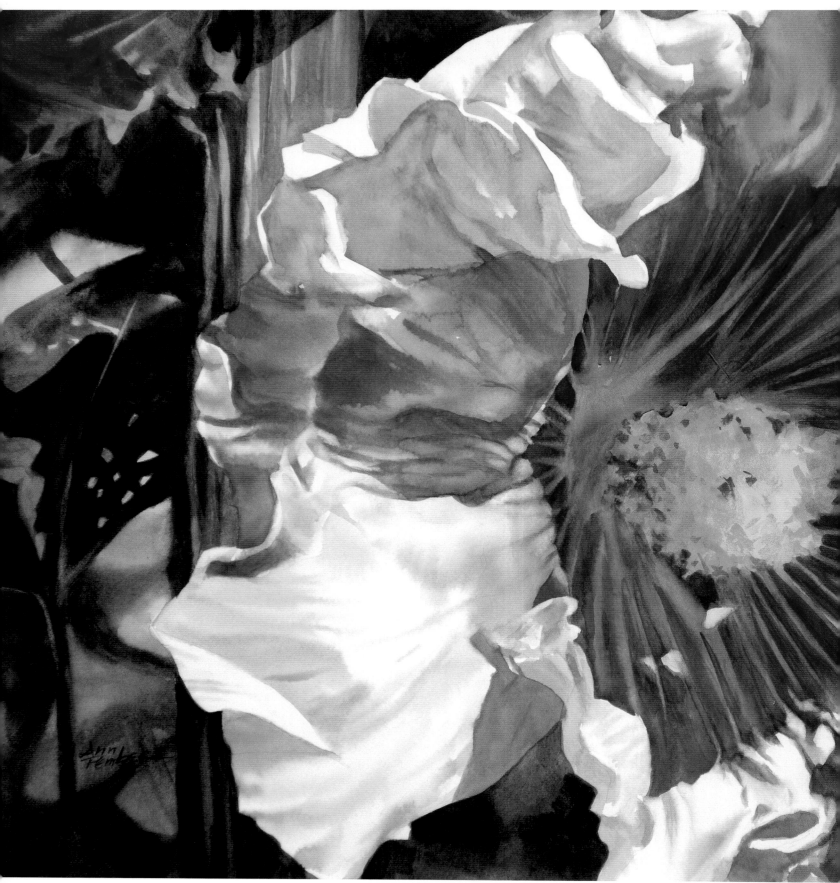

HANDSOME HOLLYHOCK
Ann Pember, watercolor on Waterford 140-lb. paper by T.H. Saunders
14" × 21" (35.6cm × 53.3cm)

Portray a Different Viewpoint

By viewing Nature,

Nature's handmaid Art,

Makes mighty things from

small beginnings grow.

—JOHN DRYDEN

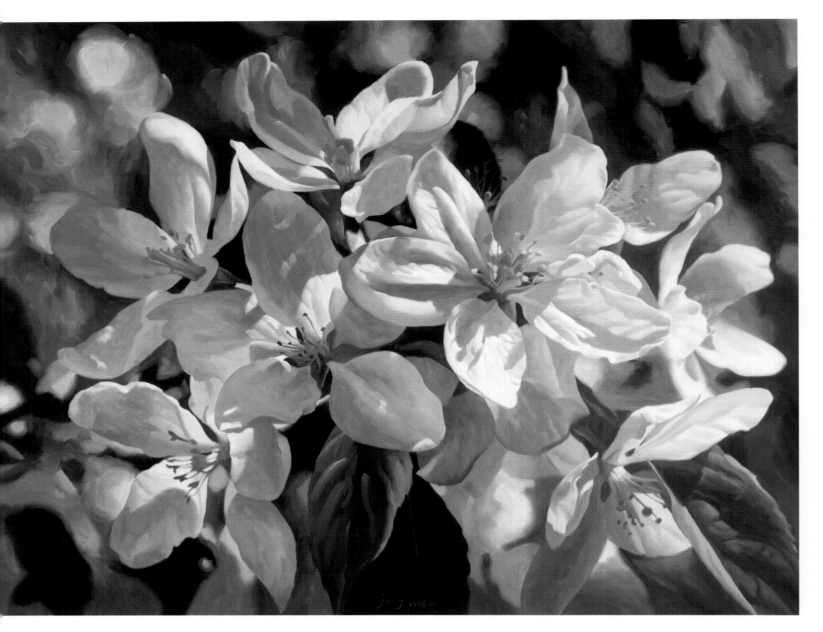

Larger-Than-Life Blossoms Demand Appreciation

MICHAEL GERRY

APPLE BLOSSOMS
Michael Gerry, oil on linen canvas
36" × 48" (91.4cm × 122cm)

What makes flowers come alive for me is the sun striking them, showing their wonderful forms and expanding their color range considerably. Backlight adds an extra element of interest. I try to give the viewer a sense of peace and drama, as well as an appreciation of the form and color of the flowers, by making them at least twenty times larger than life-size. At that size, flowers take on a different reality, becoming organically abstract (as in the work of Georgia O'Keeffe). People look at my work and comment on the detail, but I remind them that I actually use very little detail. My work only looks detailed; the illusion of detail comes from accurate values and forms. **TECHNIQUE:** There are many gessoes; some dry matte, some glossy. Very glossy gessoes don't grip the paint enough. So make them more matte by adding a soup made of powdered marble, whiting (or other calcium carbonate) and water, in a ratio of five parts gesso to at least one part "soup." Make the matte gessoes glossier by adding glossy gesso or acrylic gloss medium.

Fill the Composition With a Majestic Flower

LEE BARTH

This black lily took command of the space and sky in my floral painting. It represents a spiritual ascension into the heavens. I use live flowers, photos and memory, then transform shapes into my personal interpretation. Here, I simplified the lily into large shapes.

TECHNIQUE: I use a hand-transfer method somewhat like monotype printing. I first place oil directly from the tube onto a Plexiglas, glass or Masonite plate. When I am satisfied with the design, I then transfer the oils directly to a Mylar or paper surface by laying the original plate onto (in this case) the Mylar. If I am happy with the resulting painting I leave it alone. In some cases I touch up portions, but I never use a brush. I then adhere the Mylar to museum board, which then gets backed with foamcore.

THE BLACK LILY
Lee Barth, oil on Mylar
24" × 14" (61cm × 35.6cm)

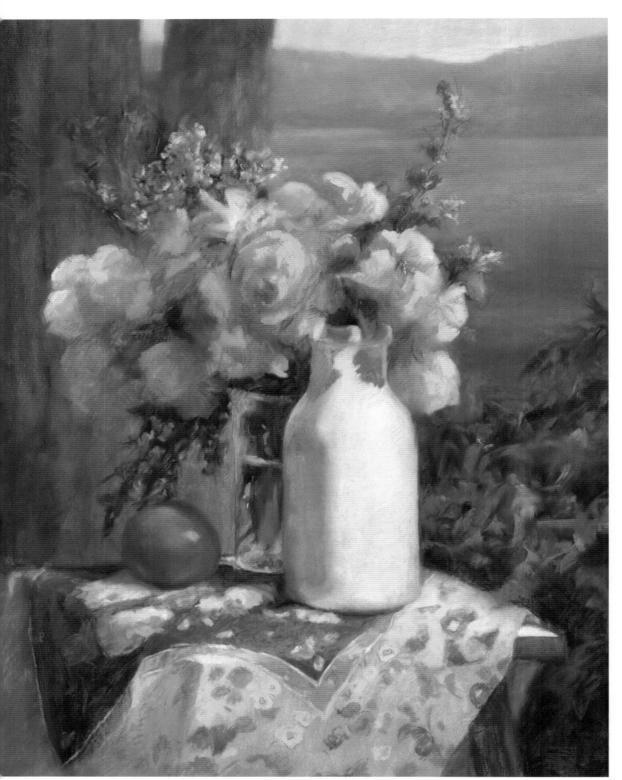

Combine a Floral Setup With a Landscape

MARY K. FORSHAGEN

On a recent trip to northern California, I was struck by the abundance of flowers and the intensity of their colors in the clear, dry air. Fortunately, our hostess provided us with unlimited access to her home and garden. So, shears in hand, I headed to the garden, then to the linen cabinet. As I set up the arrangement on the veranda overlooking beautiful Lake Tahoe, I became intrigued by the elements of the landscape in the background. I painted an oil study, seeking to unify the distant background with the colorful still life while keeping the light and feeling of northern California.

TECHNIQUE: Back in the studio with my pastels, I relied heavily on the oil study to recall my emotions and the vibrancy of the light. I chose a salmon-colored Sennelier sanded-pastel paper because it reminded me of the color of the light that day. I reserved the thickest, lightest application of pastel for the sunlit areas on the flowers and white milk bottle.

TAHOE STILL LIFE
Mary K. Forshagen, pastel on sanded paper
30" × 26" (76.2cm × 66cm)

Find a Unique Viewpoint for an Ordinary Bouquet

BILL JAMES

FLOWERS—LONG SHADOW
Bill James, pastel on Canson
Mi-Teintes paper
23" × 33" (58.4cm × 83.8cm)

I have always been fascinated with finding an interesting and unique manner to paint people or objects I see. When my daughter received a bouquet of flowers from a friend, I looked at it and decided I wanted to come up with a different way of portraying this element in a painting. The first thing that came to mind was to look down on the flowers, which automatically created a beautiful circular shape. From this viewpoint, I noticed the shadow now played an integral part in the design. To make the shadow longer and even more interesting, I placed the flowers on a floor at sunrise. With the flowers placed to the side of the painting surface and the shadow occupying more than half of the area, a unique design was created. **TECHNIQUE:** Because of the soft, fragile appearance of the flowers, I chose a smooth surface paper to work on. I took several photos of the subject and used two of them for reference. I decided to work with a complementary color combination to make the flowers and shadows really jump off the paper. By using a strong design and an impressionistic loose-color technique, the subject appears exciting and alive.

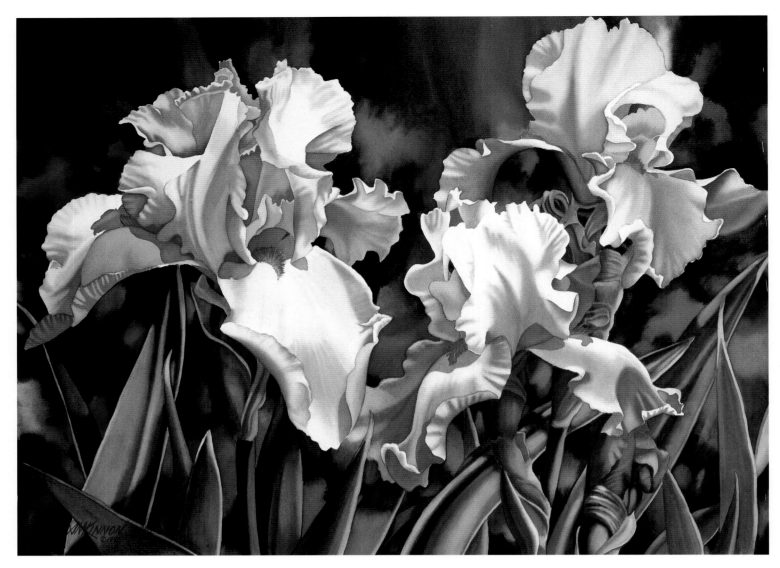

Be Creative Within Parameters

SUSAN MCKINNON

When my godmother came to me with a special commission, she arrived with a bundle of fabric and color swatches. My painting was to "pull together" these fabrics in her living room. The subject was to be iris; the colors to include were peach, purple, orange and a variety of greens. I turned to my shoeboxes, where I keep a lifetime of photos, to find everything I'd taken on irises. I selected the main flower first, then the secondary blooms, the buds and foliage, and ultimately the background. The final composition was created using elements from nine separate photographs. To add sparkle and life to the painting, dramatic sun highlights were created using the white of the paper. The foreground irises were contrasted with a dark background, which was purposely kept simple by using similar values and colors.

TECHNIQUE: In order to connect the irises with their environment, I lost some of the hard edges on the background petals. Part of the foliage was also blended into the background by placing similar values or colors next to them.

IRIDESCENCE II
Susan McKinnon, watercolor on Arches 300-lb. cold-pressed paper
21" × 29" (53.3cm × 73.7cm)

Take the Point of View of Another Flower in the Garden

SUSAN K. BLACK

Seeing these irises in my neighbor's garden, I was taken by the beautiful glowing oranges and deep purples brought out by the bright sunlight. Various light conditions during the next weeks provided opportunities to photograph the flowers from the point of view of one of the flowers. When my neighbor offered me several irises, it was time to start painting. I had to work quickly to get a lot of information down before the flowers faded. Plenty of photo references helped me to work out the lighting and to finish the painting when the flowers were gone. **TECHNIQUE:** Using heavy watercolor paper without tape or staples allowed me to maneuver it more easily. The flowers and leaves were painted slowly, sometimes using many glazes. The dark background, however, was painted quickly using straight pigments on dampened paper, most often letting the colors mix on the paper.

IRIS GARDEN
Susan K. Black, watercolor on Arches 300-lb. cold-pressed paper
41" × 29" (104.1cm × 73.7cm)

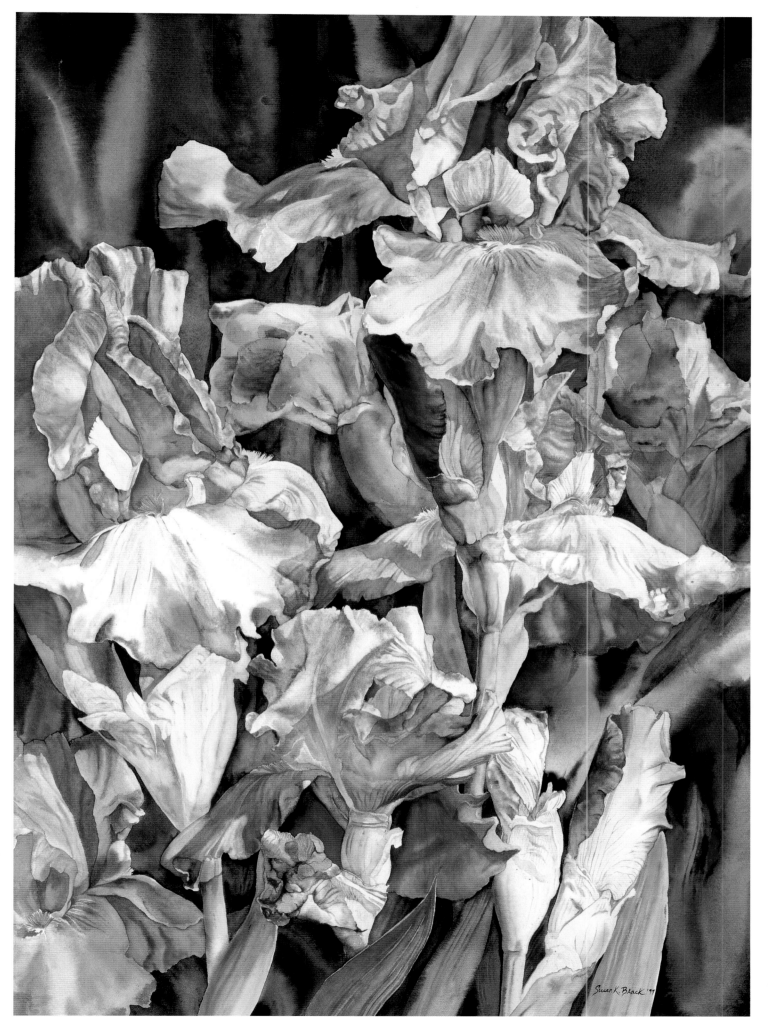

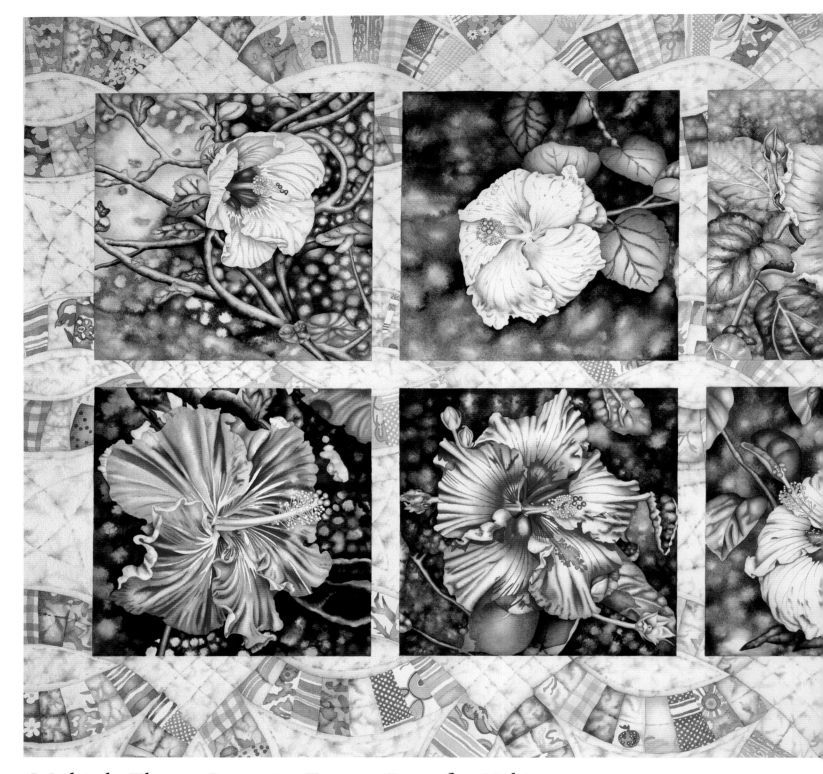

Multiple Flower Portraits Express Love for Hibiscus

MISSIE DICKENS

I wanted to paint individual "portraits" of several hibiscus in full bloom which would capture my love for their jewel-like colors. Once I chose the ten hibiscus flowers for my portrait gallery, it was fascinating and challenging to decide on an arrangement that would highlight their varied colors and reveal their gentle personalities. To connect the portraits and echo the flowers' vibrant colors, I used the curves and multicolored hues of a wedding band quilt as their background. **TECHNIQUE:** By "cutting away" the light from my paper with varying densities of color, I render my subjects in much the same way a sculptor sculpts a block of marble. Adding acrylics to my watercolors and gouaches seals the colors to the paper so that progressive layers will not disturb the underlying coats. These layers of color allow me to express many elements: luminescence and obscurity, space and depth, texture and motion, pattern and puzzle, as well as my feelings toward the subject.

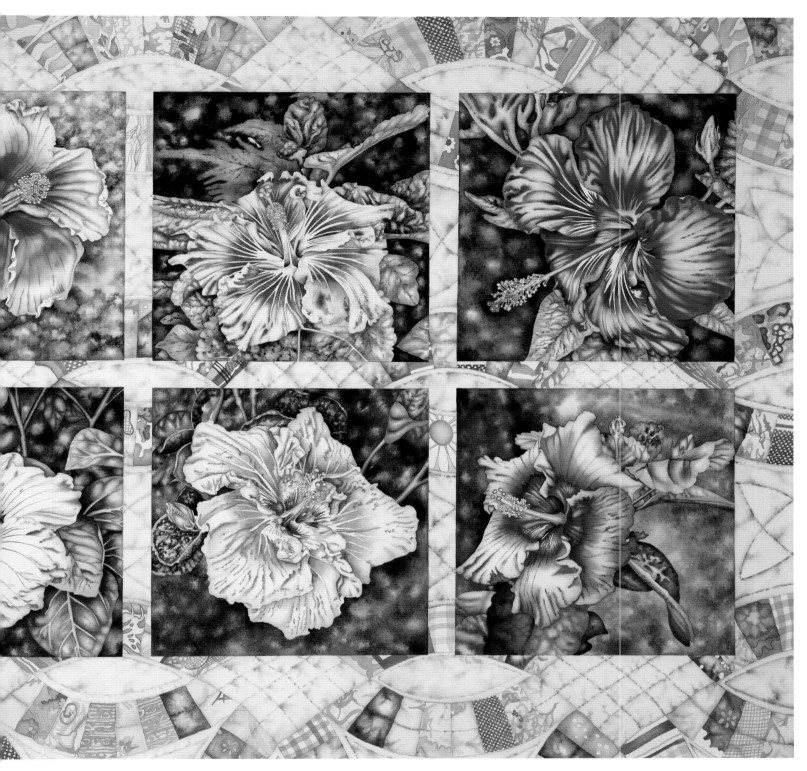

HIBISCUS QUILT
Missie Dickens, watercolor, gouache and
acrylic on Arches cold-pressed paper
28" × 60" (71.1cm × 152.4cm)

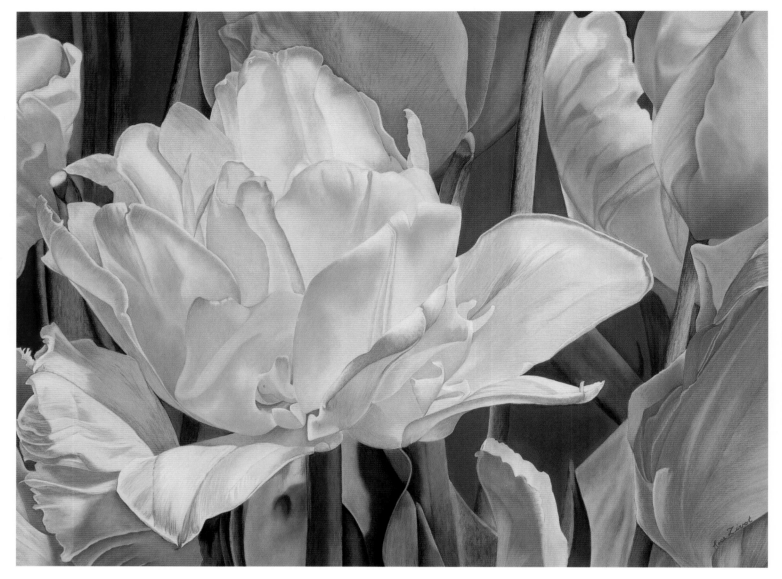

Draw Your Viewer Inside the Garden

ROSE ZIVOT

PAEONY TULIPS
Rose Zivot, pastel on Ersta
Starcke sandpaper
22" × 28" (55.9cm × 71.1cm)

In the spring, tulips are my passion because of their jewel-like colors and interesting shapes. To create a painting that would draw the viewer inside "to pick the tulips," I used bright light for deep shadows, strong contrasts and wonderful transparency that permeates the main white tulip with life. For me, pastels are a spontaneous and brilliant medium, unrivaled for painting flowers. Their unique character makes for excellence in rendering dramatic light, diverse texture and dazzling color. By giving viewers a new perspective on a familiar subject, I hope to stir their imagination to see something more wonderful than it first appears. **TECHNIQUE:** My preferred painting surface is Ersta Starcke fine sandpaper. To achieve crisp detail in my paintings, I use a variety of pastel pencils; Brunyzeel, Derwent, Conté and CarbOthello. The camera plays a vital support role because I paint slowly and meticulously. Working the background first, I try to create a rich setting that is both exciting and harmonious. The petals and leaves are worked one at a time, building layers of vivid color and texture, until they have the intensity and luminosity I like.

An Eccentric Composition
Makes the Flower Almost Human

RODOLFO RIVADEMAR

The Renaissance idea of portraying the subject in a landscape was my inspiration. I wanted the intimacy of the flower to coexist with the openness of the landscape—in this case the California landscape. In this eccentric composition (a bee's eye view combined with a more normal human perspective) the delicate and tender flower is protected from environmental elements by the foliage of the neighboring vegetation, allowing for a soft light to filter through the leaves. It is this soft, filtered light that reveals the rose in all its "humanity." **TECHNIQUE:** I started the painting by transferring a finished drawing to a sheet of Arches cold-pressed watercolor paper. Watercolor is an ideal medium for working out transparencies. Transparencies make the flower come alive. There is a subtle interplay of warm and cool colors that make it pulsate with light. My favorite colors are Permanent Rose, Alizarin Crimson and various ochres, since they all combine to create a chromatic vibrancy.

FLORAL PORTRAIT
Rodolfo Rivademar, watercolor on
Arches cold-pressed paper
36" × 54" (91.4cm × 137.2cm)

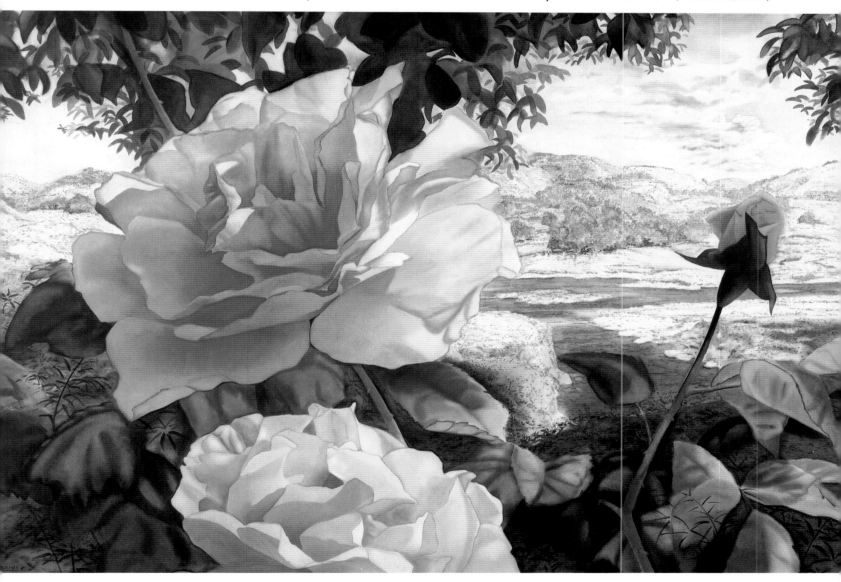

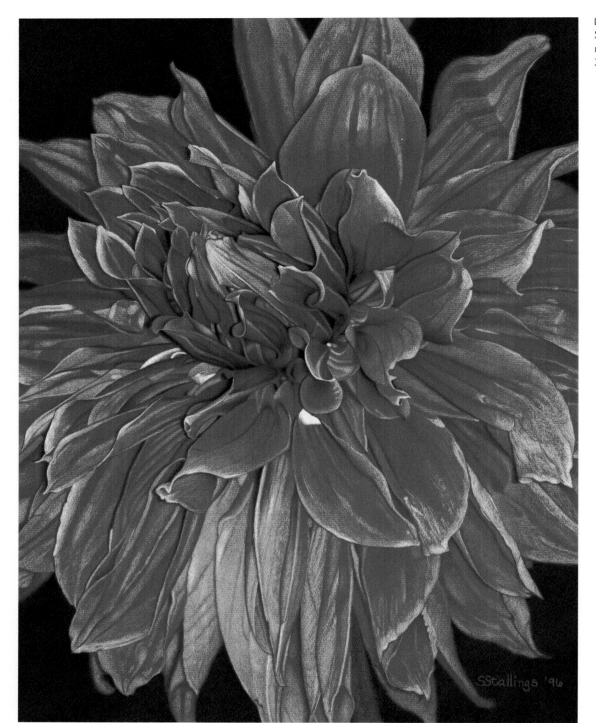

DAHLIA
Shirley Stalling, colored pencil on
red Canson Mi-Teintes paper
22" × 17" (55.9cm × 43.2cm)

Capture an Award-Winning Flower

SHIRLEY STALLINGS

My flower paintings are most often close-ups of a single exceptional blossom or a unique viewpoint.
An award-winning flower at the state fair was the inspiration for *Dahlia*. I was intrigued by the
almost drapery-like cascade of its petals, and I wanted to capture its elegant presence. Each petal
became its own composition, with colors and values unified at the end. **TECHNIQUE:** Colored pencil
is a slow technique and thus requires the artist to work from photos, especially when portraying
flowers. I am certainly not a photographer and in fact find myself being most creative when working
from a less than perfect photo. The reference photograph for *Dahlia* was washed out and poorly
focused, which allowed me room to create color and detail from my memory and imagination.
Working on a red surface further intensified the ultimate color of the painting.

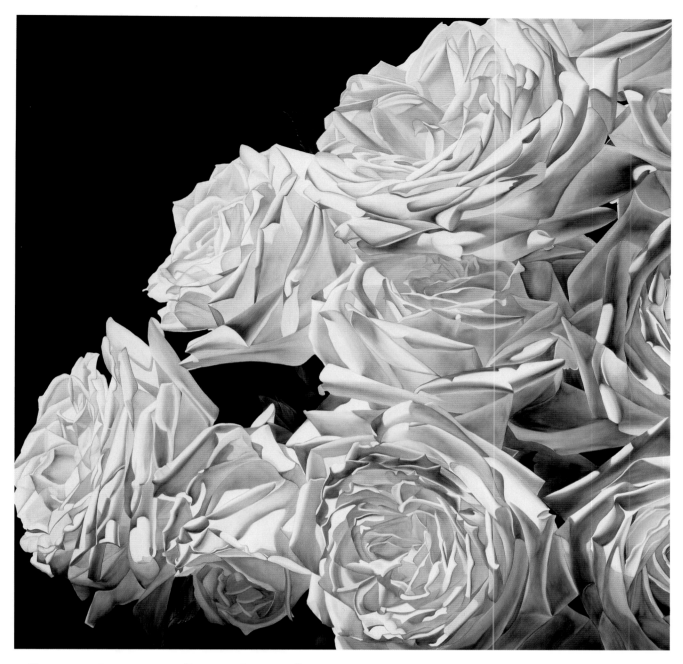

Create Drama for a Specific Viewing Location

SANDRA SALLIN

This painting began as a commission for the newly renovated Beverly Hills Hotel. It was to be placed in the public entry of the hotel. I studied the design plans of the space in order to integrate the size and concept of the work. The art consultant gave me complete freedom to create a work that would touch a large number of people. This, in fact, is precisely what has happened. Members of the hotel management have informed me that many newly married couples ask to be photographed in front of my painting! **TECHNIQUE:** From the flower mart in downtown Los Angeles, I brought to my studio a bounteous armful of white roses. This set me on a long course of sketching and photography. As ideas developed I became very conscious of the points at which the roses would touch the sides of the canvas. Twenty to forty sketches were done in colored pencils, acrylic and vellum. The final concept was then transferred to the prepared canvas. To prepare the canvas, it was stretched over a wooden panel to provide a support for the multi-layering and sanding of gesso. Nova gesso is applied four times per day, with drying and sanding between each application. This process is repeated each day until the surface feels like a soft, smooth flower petal.

WHITE SHADOWS
Sandra Sallin, oil on canvas over panel
36" × 36" (91.4cm × 91.4cm)

8

Stress Contrast

Flowers are the sweetest

things God ever made and

forgot to put a soul into.

—Henry Ward Beecher

THE OLD SHED
Lisa Fields Fricker, oil on linen canvas
18" × 24" (45.7cm × 61cm)

Combining Mediums for Glowing Lights/Rich Darks

BARBARA SIMMONS

These purple and white bearded irises miraculously appear every June in my garden. They have become the subject of a continuing study over many years. Here, I was trying to emphasize the velvety, rich, dark-purple petals contrasted with the intense whiteness of the heads. I felt that watercolor would not achieve the effect I was looking for, so this work became one of my first attempts at combining acrylics and watercolor. **TECHNIQUE:** When I work in acrylics on paper, I paint many layers of transparent washes. In this painting, the darkest areas were painted with layers of analogous colors from the violet family. Yellows, blues and greens were used for the middle values. The whites were created with the cool primaries in watercolor. This media combination gave me the "wow" I'd been searching for.

IRISES
Barbara Simmons, acrylic and watercolor on 300-lb. cold-pressed paper
22" × 30" (55.9cm × 76.2cm)

Paint a Flower's "Best Side"

NORMA AUER ADAMS

One usually sees flowers painted head-on. In this close-up profile view I saw an exciting image filled with dramatic diagonals, including the flower and the stems and foliage crisscrossing each other. The spreading arc of the large chrysanthemum flower filled with warm light dominates the painting, while the dark foliage creates an intricate pattern against the clear, white background. **TECHNIQUE:** I use an airbrush and thinned acrylic paints. I prepare the painting surface with layers of gesso, and transfer a full-sized drawing of the image to this surface. To create soft edges, I airbrush freehand; to create crisp edges, I use FriskFilm. Because airbrushed paint is thin and transparent, much of the color mixing is done on the painted surface by overlayering.

CHRYSANTHEMUM PROFILE
Norma Auer Adams, acrylic on Arches cold-pressed paper
27" × 24" (68.6cm × 61cm)

Rich, Vibrant Color at Low-Angle Lighting

SHARON TOWLE

I was inspired by the deep color of the common California poppy and decided to contrast it with the tapestry and a background of other flowers and fabrics. I wanted to keep the painting somewhat loose, with sharp detail in the focal area and only hints at detail in the rest of the painting. I get really wild at the sight of these flowers with their rich, juicy, vibrant colors. To further enhance this alive feeling, I used a low lighting angle. The low lighting also brings out contrasting elements: bright orange vs. deep purple; bright whites vs. deep darks; plain fabric vs. patterned fabric. After the initial emotional impact of what I'm seeing, I find the actual painting to be more of an intellectual process, comparing contrasts in light/dark and variations of color. **TECHNIQUE:** I generally set up my still lifes on a table in my patio, photograph them when the light is just right and paint from the photos. Other times I'll photograph individual things and put them together later in a painting. Clear, clean, brilliant paints are my key to vibrant flowers.

POPPY OPULENCE
Sharon Towle, watercolor on 180-lb. cold-pressed paper
22" × 30" (55.9cm × 76.2cm)

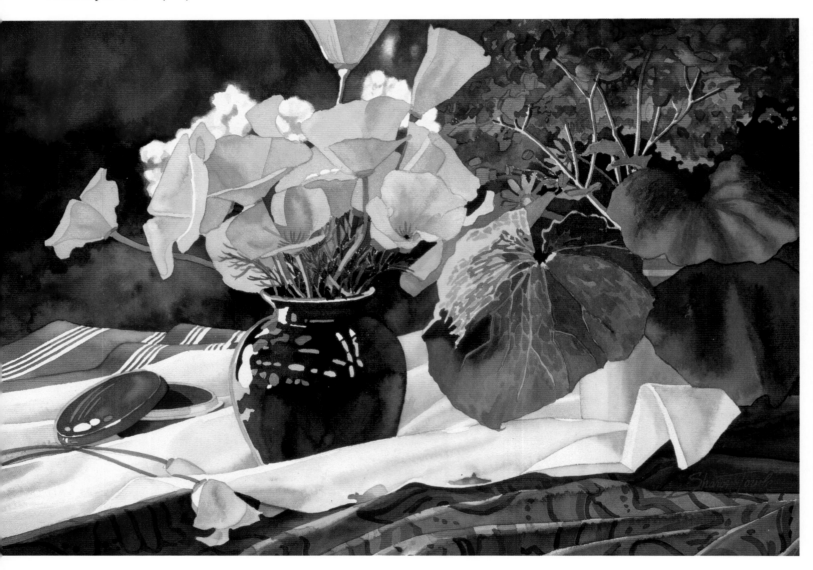

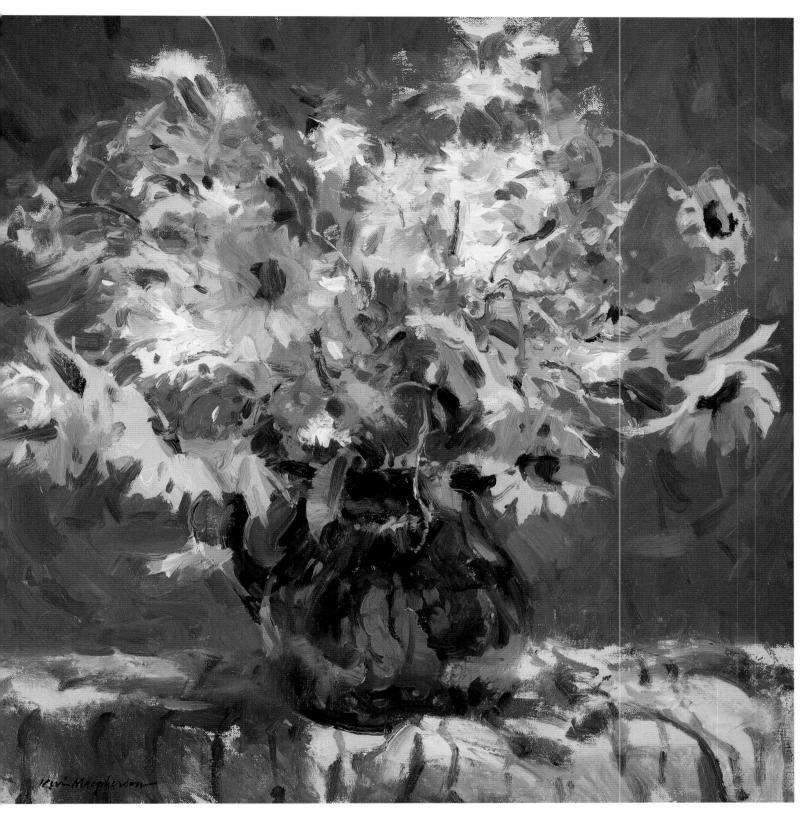

TURQUOISE MEXICAN PITCHER
Kevin D. Macpherson,
oil on linen canvas
20" × 20" (50.8cm × 50.8cm)

Brilliant Sunlight Makes Complements Sparkle

KEVIN D. MACPHERSON

I picked these beautiful wildflowers on my morning walk. I have a setup on my deck for outdoor still lifes so I can capture the brilliant sunlight. I plopped these flowers in the turquoise pitcher to set up a strong complementary contrast between the brilliant yellows and cool blues. The sunlight intensified this contrast, which was prudently set off by a warm but neutral background and the addition of some white flowers and foreground. **TECHNIQUE:** When painting still life outdoors, you don't have the luxury of time. The fast-changing light creates an atmosphere of rushing energy that comes forth in the application. I like to try to bring that same energy into the studio.

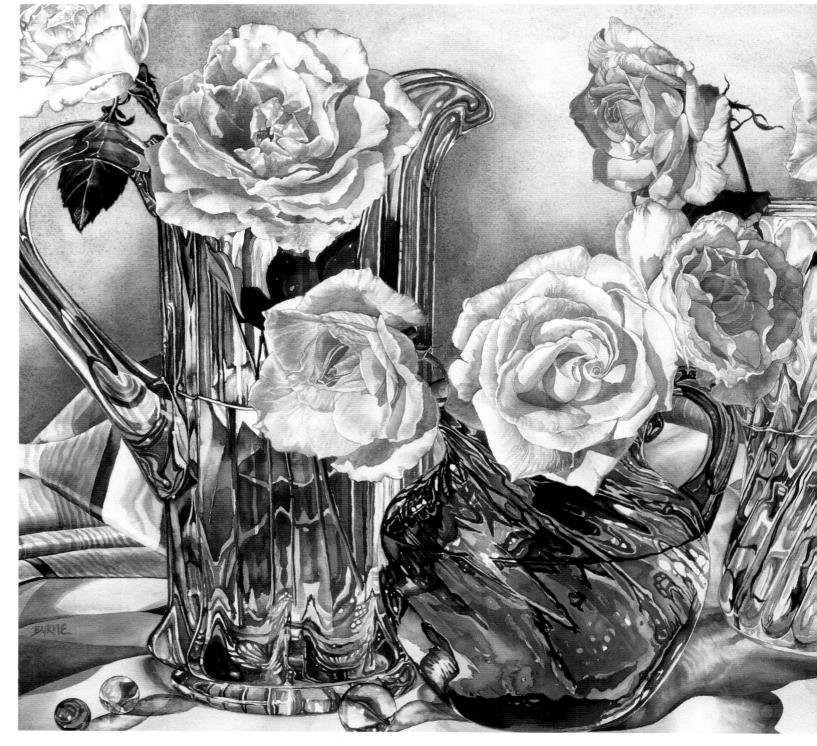

Contrasting Flowers and Glass in a Major Work

MARY GREGG BYRNE

This painting is one of a series depicting flowers and glass and crystal together. Many of the objects I portray are antiques, and I enjoy contrasting their age with the ephemeral beauty of flowers. These paintings become treatises on the natural and the created, the beauty of things that survive and things that will not, and the nature of time. I am a watercolor devotee and find the media well-suited to transparent glass and sometimes translucent flowers. The wonderful colors of flowers are a joy to paint. I prefer homegrown flowers or wildflowers because I treasure their imperfections and their scent. **TECHNIQUE:** This is the largest painting I have ever done, and it was an adventure fitting the paper into my compact car, as well as finding an effective way to work on it in my tiny studio. It took an entire summer to finish. Anyone attempting large work for the first time will find design and value sketches extremely important. It is difficult to see the entire painting as you work. Good planning is essential. I always have the glassware with me as I paint, but must rely on photography to help me remember the flowers with long projects such as this.

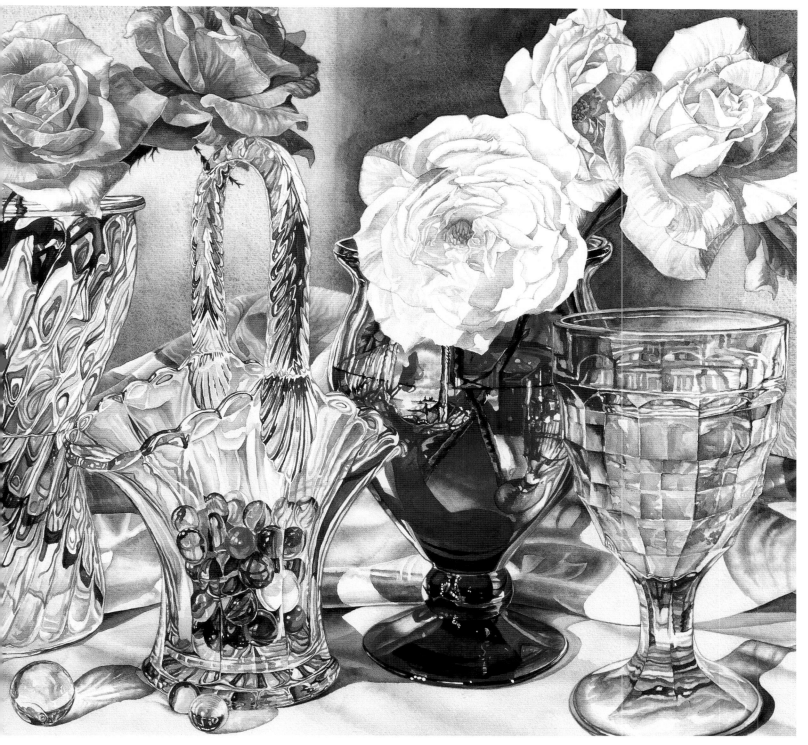

VICTORIAN ROSES
Mary Gregg Byrne, watercolor on cold-pressed paper
26" × 56" (66.0cm × 142.2cm)

LAMPOST AND BOUGAINVILLAEA
Linda Kooluris Dobbs, watercolor on
Arches 300-lb. rough paper
28" × 19" (71.1cm × 48.3cm)

Saturated Color and Crisp Form under Overcast Skies

LINDA KOOLURIS DOBBS

Coming down these steps in the fishing village of Agia Galini on Crete, I was enveloped by this scene. While I contemplated the zigzagging shapes and lines, syncopated music echoed in my head. In spite of an overcast sky and practically no shadows, saturated color and crisply defined shapes appeared in the bougainvillaea, the other flowers and door. To make this image work, I was ruthless in deciding what to leave out. **TECHNIQUE:** The background color of walls and steps were painted in the higher, paler values of transparent paint. I let the colors blend with wet-into-wet technique. This provided a clear blanket upon which to lay saturated flower colors. Keeping the edges fairly sharp (wet-on-dry), I used Old Holland Scheveningen Rose Deep, Winsor & Newton Permanent Rose, Permanent Carmine, Permanent Alizarin Crimson with Cobalt Violet and Winsor Violet.

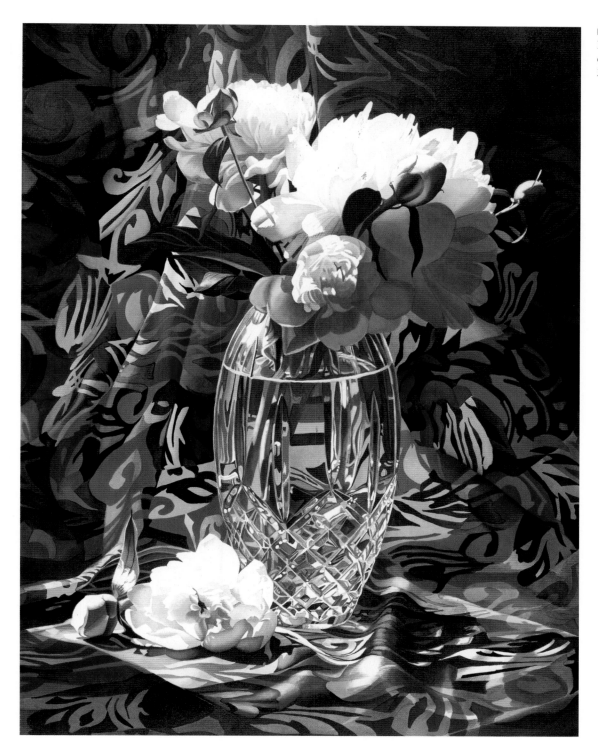

FESTIVE WHITE PEONIES
Barbara K. Buer, fluid acrylic on
cold-pressed paper
30" × 22" (76.2cm × 55.9cm)

Drama in White and Bright, Simple and Complex

BARBARA K. BUER

My white tree peony has been the inspirational subject for many of my most successful paintings. Each spring as it once again blooms in all its glory, I am challenged to come up with still one more setting in which the white peony can shine. Recent gifts of a silk scarf and a crystal vase proved to be "just what the doctor ordered." Keeping the brilliance of the white flower, the sparkle in the crystal vase and the brightness of the colors in the scarf from vying with each other for attention was the challenge in this painting. **TECHNIQUE:** I use fluid acrylics in a transparent glazing technique, allowing the white paper to reflect through the transparent glazes. This gives the colors their brightness. When painting white flowers, I exaggerate the whites by keeping their negative spaces in sharp contrast. I compose and design a painting by doing numerous setups of the subject matter and, using only natural sunlight, photograph the setups from all angles.

A Variety of Contrasts Get Attention

JUDY MORRIS

I am enchanted by the colors and textures found in the villages of Mexico. The buildings give me a chance to paint textures; the flowers, a chance to paint color. The shadows are filled with reflected color from the bougainvillaea that seems to grow wild everywhere! In this painting I've set up several contrasts: the purple-red flowers against the green leaves as color contrast, the sunlit wall against the deep shadows as value contrast and the rough texture of the entrance against the smooth texture of the building behind it as texture contrast. These interacting contrasts make the painting more exciting. **TECHNIQUE:** I couldn't paint bougainvillaea without using Winsor & Newton's Brilliant Red Violet Designers' Gouache. It's the perfect color! Neither could I finish this painting without adding cloissoné lines around the shapes that create the flowers. It's one of my favorite painting techniques and a very important part of my personal painting style.

THE ENTRY
Judy Morris, watercolor and gouache on Arches 300-lb. cold-pressed paper
21" × 28" (53.3cm × 71.1cm)

Push the Limits of Color While Contrasting Opposites

ROBERT A. JOHNSON

In this painting I wanted to contrast visual opposites and push their color effects, while keeping the work honest and credible. The muted Oriental print in the background sets up basic color contrasts between light and dark tones of the flowers and leaves. The vertical thrust of the peonies on the left are enhanced by the somewhat horizontal masses of the background. Likewise, the beautiful, rounded forms of the peonies and the vessels contrast with the overall flatness of the background print.

TECHNIQUE: The medium-weight linen canvas was double-sized with rabbitskin glue and primed with a white lead surface, which is relatively nonabsorbent and preserves the freshness of the paint. I first applied a thinned wash of Sap Green and Indian Yellow. Heavy impasto paint in the light gives the peonies power. I used bristle filbert brushes nos. 2-8, with flat sable or mongoose brushes for some of the petals and leaves to capture their sharp edges and delicate quality.

PEONIES IN AN ASIAN VASE
Robert A. Johnson, oil on hand-prepared double-weave linen canvas
32" × 28" (81.3cm × 71.1cm)

MOTHER NATURE'S LACE
Susanna Spann, watercolor on Arches 300-lb. paper
40" × 50" (101.6cm × 127cm)

Create a Story or Symbolism

And I will make thee beds of roses

And a thousand fragrant posies.

—Christopher Marlowe

Combine Disparate Subjects for a Common Motif

LYNDALL BASS

The season of springtime forms the theme of this work. It is meant to convey freshness, joy and warmth. The poster, found at the archeology museum in Florence, was the starting point for the painting. Its color harmonies and mood led to the daffodils, just typical potted gift flowers from the local market. The combination of these two speak of the "trumpeting forth" of spring in the sound of the flute and the trumpet shape of the daffodils...and the little ringing bells of the lily of the valley. **TECHNIQUE:** The daffodils were painted first, after carefully sketching out the composition and proportions. The flowers have to be caught while they are living, and the rest of the painting worked around them.

HERALD OF SPRING
Lyndall Bass, oil on linen canvas
20" × 14" (50.8cm × 35.6cm)

Feel the Beauty of Early Autumn

ALEXANDER D. SELYTIN

A kind neighbor shared treats from his garden, which included these unique pansies. While most see small, cheerful faces in these bright blossoms, I was struck by the unusual colors. They remind me of the wonderful contrasts of colors found in autumn. These pansies are found in the fall when the weather cools in September to give one last glimpse of the best and brightest colors nature offers. **TECHNIQUE:** I always try to honor the integrity of the subjects I paint by duplicating in detail the best they offer. I want the viewer to feel all their beauty. If you look closely you may feel the need to brush away a few dewdrops. I add them to keep the memory of the bouquet alive and fresh.

KEEPSAKES
Alexander D. Selytin, oil on linen canvas
11" × 14" (20.8cm × 35.6cm)

Paint Nature's Movement and Change

ZHANG WEN XIN

There is a Chinese poem, written by a king of South Tong when he was captured as a slave by another king. It says, "The falling flower blamed the east wind in no sound." The east wind means the late spring wind. It brings the rain and blows the springtime, along with many flower petals, away. The king was lamenting that the good time is passing away like the flowers. This generous gift of beauty just exists in a twinkling of ruthless time. As an artist, however, I never complain of movement and change in my subjects—it is the rule of nature. In fact, that very movement is the subject of my paintings. When I face a group of flowers, I like the bulging bud, the open bloom, full of life and change. I like, too, the flower as it seems to get tired, still full of beauty. **TECHNIQUE:** I like my brush to accompany nature's glorious journey through movement and change. I always paint in natural light, usually from a skylight.

FREESIA
Zhang Wen Xin, oil on canvas
20" × 20" (50.8cm × 50.8cm)

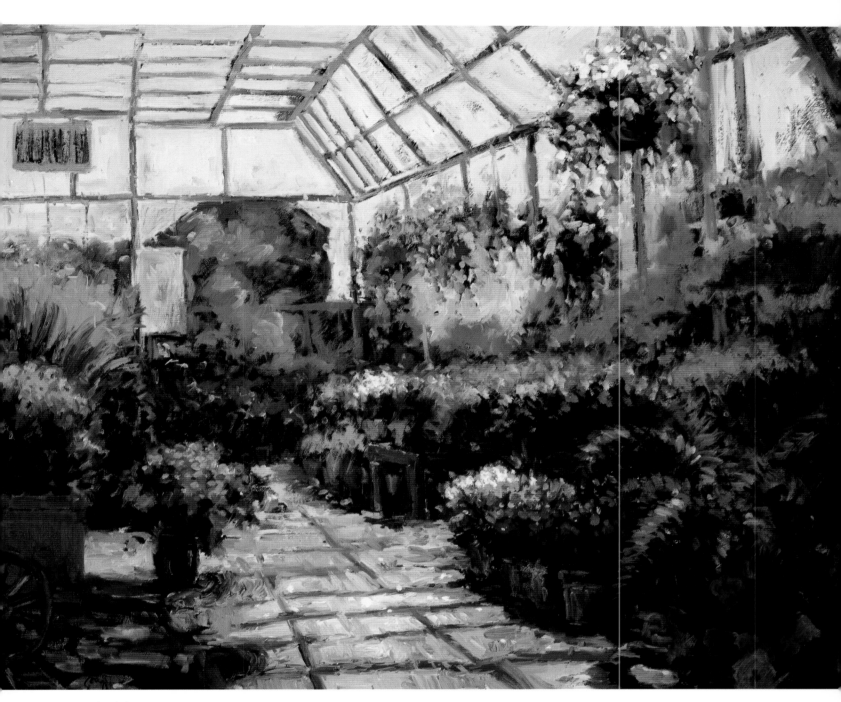

Paint What You Smell and Hear Along With What You See

DOUG GORRELL

This painting was inspired by a beautiful flower market I discovered while painting in St. Etienne, France. Upon entering the greenhouse, I was greeted with the rich warm aroma of plants and earth, mixed with the intoxicating scent of nature's perfume. I began making notes of my observations. I noticed soft colors reflecting on glass panels. I studied the color harmony from one group of blossoms to the next. I noticed the color in the shadows, setting off the strength and delicacy of the flower masses. I heard muted voices in buildings nearby. The stillness, warmth and beauty that summer morning filled me with a desire to bring my personal vision to life on canvas. **TECHNIQUE:** I started with a rough drawing, establishing perspective and various flower shapes. Focusing on the light source, I painted the top panels of the greenhouse. This is the lightest area of the painting. I then indicated the darkest area. With my lightest light and darkest dark established, I began adding thin, colorful washes to the floral shapes, followed by thicker applications. To finish, I softened some edges and checked color and contrast.

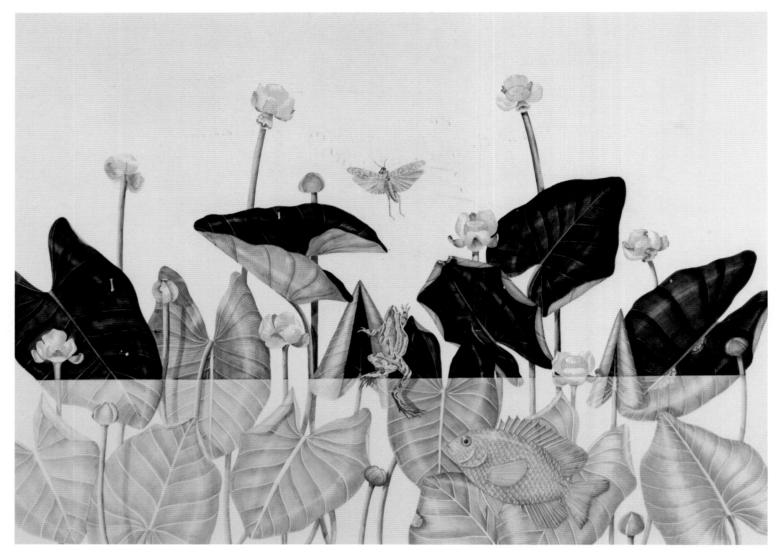

Mix Mediums to Help Tell a Story

MARI M. CONNEEN

In painting *Catch Me If You Can*, I wanted to break up the watercolor and also establish an indication of a waterline. By changing from watercolor to graphite, the drawing served to soften the dark greens of the leaves and also made an illusion of water lilies floating in motion, under the water. As I was looking at the pond, insects, fish and frogs were prominent. This sparked the idea of communicating a story, as well as a painting. **TECHNIQUE:** Working on Strathmore illustration board, frisket paper was used at the "waterline" to give a sharp edge as I painted the watercolor. Paint was applied with a series of washes and then wiped off. A final wash of Cadmium Yellow and Aureolin was used over flowers, stems and leaves.

CATCH ME IF YOU CAN
Mari M. Conneen, watercolor and graphite on Strathmore cold-pressed illustration board
29" × 34" (73.7cm × 86.4cm)

"Just living is not enough,"

said the butterfly.

"One must have sunshine,

freedom and a little flower."

—HANS CHRISTIAN ANDERSEN

Flowers and Reflections

JANIE GILDOW

My first memory of flowers is always accompanied by the memory of sharp tapping. At age four I was filled with delight in picking the neighbor's hyacinths. Their fragrance was magic. The tapping came from the window above as the owner was horrified by my growing bouquet. Her scowl and subsequent call to my mother convinced me that some flowers are not to be picked. To me, flowers are exotic and mysterious. Their color is enchanting. Their fragrance summons up memories and emotions. Here, they are juxtaposed with the coldness of glass and metal to better emphasize their softness and subtle color. The title refers to the fact that I, who said I would never use black in a colored-pencil piece, ended up doing just that. To sufficiently lower the value of the background, the only pencil I could find with enough power was the black, hence *Broken Promise*. **TECHNIQUE:** My technique of color application is called layering. Each layer of semitransparent color can each be seen through all the other layers, producing rich and elegant color mixtures not possible with other media. I use complements to establish values and enrich shadows with a modified grisaille. Then I apply the local color. *Broken Promise* took 112 hours to complete.

BROKEN PROMISE
Janie Gildow, colored pencil on three-ply Strathmore 500 series bristol, plate finish
13" × 18" (33cm × 45.7cm)

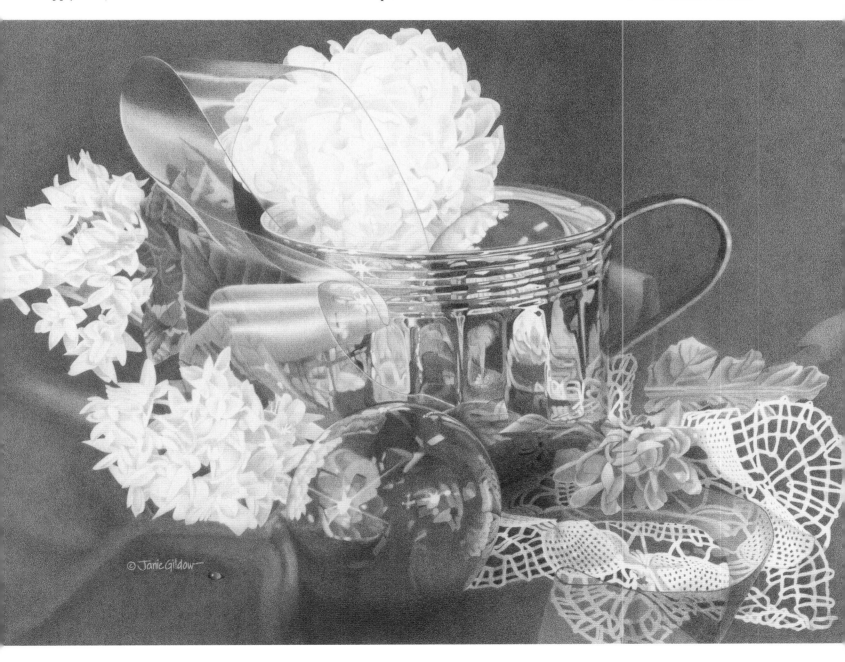

Paint a Hidden Message in Organic Forms

PENNY SOTO

When I first saw this little scene in San Juan Baptista, California, it just quietly said "watercolor." The town is very old, like the picket fence that the morning glories are growing on. The challenge was to paint the delicate little flowers against the harshness of the wood fence. I remember these flowers from when I was growing up in California, and what a romance they had about them. The way the vines curved just begged to "spell something out" in the painting. I painted the whole painting with transparent watercolor and later came back into it and spelled out the lettering "I LOVE YOU," by glazing over areas with a darker color, painting negatively. I later came in with an airbrush and "glazed" over the shadows in the fence and sky, and punched up the flowers with a transparent color. **TECHNIQUE:** The reason for the airbrush was so that it would not disturb the watermarks and brushwork that the watercolor made. I utilized the white of the paper for the fence and drybrushed the surface of the fence wood gently with transparent warm and cool colors. There are five "I LOVE YOU" phrases hidden in the painting, thus the title *Lost Loves*.

LOST LOVES
Penny Soto, watercolor
30" × 40" (76.2cm × 101.6cm)

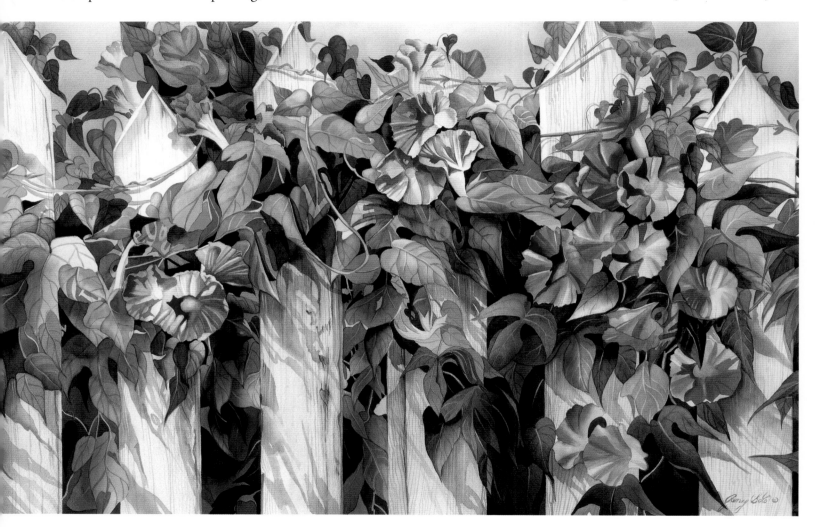

A morning-glory at my window satisfied me more than

the metaphysics of books.

—WALT WHITMAN

Flowers Emerge from the Paint to Symbolize Power

WENDY MATTSON

Walking in the garden of a grand estate, I was captivated by these gladiolas that were not only bathed in magnificent light, but were flourishing despite their fenced-in confines. I was struck by the lesson in front of me. How do we react to the limitations seemingly imposed on us? Their glory was a clear illustration of the power, strength and infinite capacity of being. In order to best communicate these ideas, I chose to let the floral forms flow and emerge from the paint rather than be imposed on it. **TECHNIQUE:** I masked the fence and then saturated 300-lb. paper. I then applied strong color, being careful to leave white areas where the glads would appear. I lightly sprayed and tilted the paper, allowing the colors to blend. The gladiolas were lifted from the paint using a sponge, and when dry, the painting was further developed. The biggest challenge in a garden scene? Green. I was careful to vary the shades and mix my own colors.

Childhood Memories Suggest Flower Placement

KAREN HONAKER

When I was a child in my home state of Nebraska, fields of sunflowers left an enormous impression on me. Driving by a field in the morning, every sunflower was facing east. Later in the day, I was stunned to see that each and every sunflower in the same field was facing west. In this painting, I replicated the sunflowers' unified movement. **TECHNIQUE:** With the aid of a scanner and a graphics program, my source material undergoes an exhilarating transformation. In this painting, I combined elements from four of my photographs and then scanned in the blue bottle from a bath catalog. For me, this preliminary computer work replaces the need to sketch the image. I can move, resize or rotate the objects until I achieve the ideal composition.

SUNDANCE
Karen Honaker, watercolor on Winsor & Newton 260-lb. cold-pressed paper
29" × 21" (73.7cm × 53.3cm)

Paint a Story Without Words

MICHAEL P. ROCCO

One does not need to know the title of this painting to realize certain things about its locale—the warm temperature and the fact that it is somewhere other than the United States. My paintings tell a story and hopefully evoke an emotional response from the viewer. I am not a painter of flowers, per se; however, this scene was quite moving. The contrasts the composition presented both visually and in ethereal qualities was my motivation: the busy growth of the bougainvillaea against the simplicity of the sky; woody branches foiling soft leaves and petals; "sunlit" shadows creating dimension, warmth and movement. **TECHNIQUE:** In this painting I made extensive use of masking procedures, using liquid frisket to cover flowers, leaves and branches and masking tape in other areas. This allowed me to brush in the sky using a 11/2-inch flat brush with horizontal strokes, blending from top to bottom into the darker shore area in one quick sitting. This is the only section that was painted with acrylic, and use of value is critical to attain spatial relationship.

ON CAPRI
Michael P. Rocco, watercolor and acrylic on 140-lb. cold-pressed paper
14" × 21" (35.6cm × 53.3cm)

Brightly Colored Wildflower Field

JUNKO ONO ROTHWELL

This is an old farm in a suburb of Atlanta. Nobody lives there anymore, so the fields are covered with wildflowers. I opened the gate to the field, went down the hill and stood there for a long time. Suddenly I saw a deer cross the field, and then it was quiet again. This area is being developed quickly; the wildflower field will not remain for long. It will be paved for a shopping mall or development. **TECHNIQUE:** I underpaint with pastels combined with turpentine; after that dries, pastels are applied again. I mainly use Rembrandt, with Schmincke and Sennelier sometimes used for final details.

FIELD OF WILDFLOWERS II
Junko Ono Rothwell, pastel on German Ersta sanded pastel paper
21" × 27" (53.3cm × 68.6cm)

To me the meanest flower that blows can give/

Thoughts that do often lie too deep for tears.

—WILLIAM WORDSWORTH

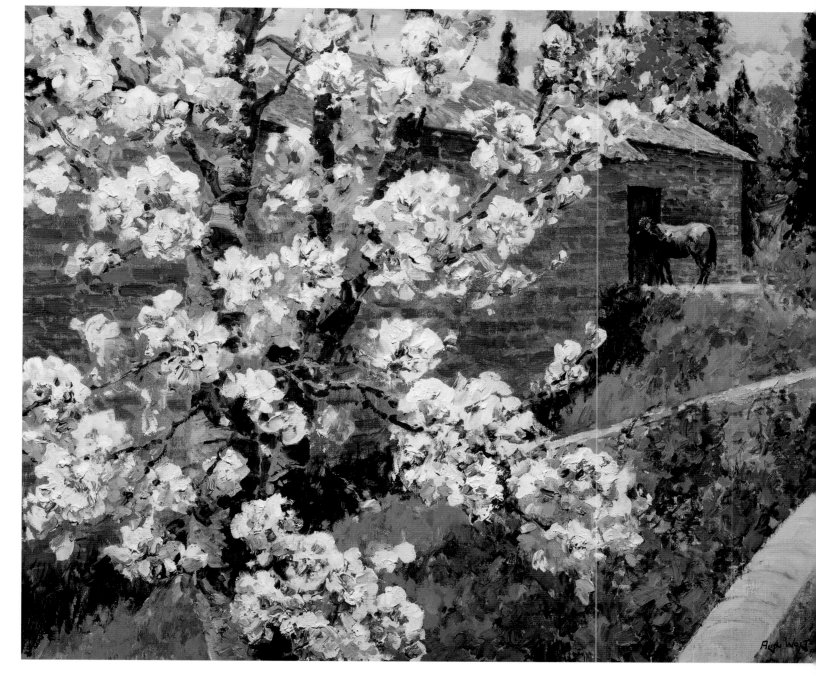

Spring Reveals the Handiwork of God and Man

ALAN WOLTON

SPRING IN THE AIR
Alan Wolton, oil on linen canvas
40" × 48" (101.6cm × 122cm)

The charming medieval farm, Casa Andreina, in the heart of Italy's Tuscany, was adorned by the jewels of spring. The owner was tenderly grooming his old mare. "I love this old girl more than anything else in the world," he said, quickly adding, "Except my lovely wife, of course!" The rugged old stone buildings with their tiled roofs so complemented the pristine tenderness of the apple blossom it seemed a presentation of man's endeavor and God's perfection. When traveling, or even with local subject matter, I always attempt to allow a totally new energy to touch me for each painting. If we can cease our intellectual analysis and allow that which is greater to register on the screen of our minds, the most boring scene will become divinely inspired. **TECHNIQUE:** The secret of flower painting is to play the opaques against the pure sensuality of the transparent pigments. Even in the actual blossom, the colors are not truly opaque. I am not a botanical illustrator, but rather attempt to impart the glorious effects of the Lord's creation. My first thirty years of professional painting were fanatically plein air. Today, I utilize my "apprenticeship to nature" in my studio—ever inspired by new visual excitement.

Celebrate Nature's Abundance

CAITLIN E. FLYNN

My artwork focuses on honoring the sacred and primal elements of nature. *Celebration* was inspired during a trip to Hawaii during the peak of orchid season. I came upon an abundant grove of flowering cymbidium orchids that took my breath away. I was struck by the mesmerizing beauty, interconnecting gestures and warm colors of the orchids. The clusters seemed to gather together individual personalities into a community of energy, transforming into a group of voices for a choral masterpiece. It is called *Celebration* in order to honor the beauty of the mystery of creation as an inherent gift of our natural world. **TECHNIQUE:** My oil painting technique, in the tradition of the Dutch masters, requires building two monochromatic opaque layers of oil, then glazing and blending additional layers of transparent oils to produce a rich, textureless and highly detailed result. I begin with a value study of the flowers and mix opaque paints (Titanium White, Mars Red, Winsor Yellow) to complete the monochromatic study and establish a warm base. Then I begin to develop the range of colors in the composition by applying cool opaque mixtures of paint, such as gray-greens, blues, gray-pinks, etc. The third layer begins by applying transparent glazes to further develop color and light. The fourth and ongoing layers of glazing involve alternating cool and warm transparent oils to establish depth and brilliance. A final layer of oil is applied with a small brush to complete details.

CELEBRATION
Caitlin E. Flynn, oil on panel
17" × 30" (43.2cm × 76.2cm)

Organic Movement Celebrates Life

VIE DUNN-HARR

Writing poetry along with each painting exposes my heart and tunes the hearing of my spirit to each flower creation. Sometimes the painting inspires the poetry, and other times the poetry inspires the painting. My paintings derive from a sincere heart. **TECHNIQUE:** *Renaissance Iris* began with a Liquin wash, which brings a fluid and dramatic movement into the design. I wanted the movement to evolve into leaves and vice versa. The pillar and vine were a spontaneous and pleasing development.

RENAISSANCE IRIS
Vie Dunn-Harr, oil and Liquin on canvas
36" × 30" (91.4cm × 76.2cm)

NORMA AUER ADAMS
c/o Peter de Jong
Microsoft Corporation
1 Microsoft Way
Redmond, WA 98052
p.113 *Chrysanthemum Profile* © Norma Auer Adams

CATHERINE ANDERSON
4900 Trinity Rd.
Glen Ellen, CA 95442
p.73 *Harbor Fog* © Catherine Anderson, private collection

KURT ANDERSON
275 E. 4th St., #750
St. Paul, MN 55101
(612) 292-9560
pp.40-41 *Five Oranges* © Kurt Anderson
p.44 *Wrapped Orange* © Kurt Anderson

JOE ANNA ARNETT
P.O. Box 8022
Santa Fe, NM 87504-8022
p.35 *Carnival* © Joe Anna Arnett
p.88 *Dahlias and Golden Screen* © Joe Anna Arnett

GLORIA MALCOLM ARNOLD, C.A.
301 E. Center St.
Lee, MA 01238
p.43 *Tea With Alma* © Gloria Malcolm Arnold

JAMES ASHER
P.O. Box 8022
Santa Fe, NM 87504-8022
p.69 *Market Day at L'isle Sur la Sorque* © James Asher

JOANNE AUGUSTINE
P.O. Box 412
Rocky Hill, NJ 08553
p.72 *Island Dandelions* © Joanne Augustine, collection of the artist

ANNE BAGBY
242 Shadowbrook
Winchester, TN 37398
p.36 *Country Red* © Anne Bagby
p.45 *Golden Delicious* © Anne Bagby

LEE BARTH
2221 Birch Ln.
Park Ridge, IL 60068
p.99 *The Black Lily* © Lee Barth

LYNDALL BASS
Lyndall Bass Fine Art Studio
1535 Grant St., Suite 315
Denver, CO 80203
p.124 *Herald of Spring* © Lyndall Bass

MICIOL BLACK
4437 San Juan Dr.
Medford, OR 97504
E-mail: mitch19@mind.net
(514) 779-3273
p.8 *Hollyhock I* © Miciol Black, collection of the artist
p.19 *Gerber Daisy* © Miciol Black, collection of the artist
p.80 *Calypso* © Miciol Black, collection of the artist

SUSAN K. BLACK
6874 Kingston Cove Ln.
Willis, TX 77378
E-mail: SKBLACK@compuserve.com
p.103 *Iris Garden* © Susan K. Black

KATHERINE BLESER
1935 Ponce de Leon Ave., N.E.
Atlanta, GA 30307
p.15 *Bird of Paradise* © Katherine Bleser

BARBARA K. BUER
5438 Oxford Dr.
Mechanicsburg, PA 17055
(717) 697-6505
p.119 *Festive White Peonies* © Barbara K. Buer

MARY GREGG BYRNE
1018 15th St.
Bellingham, WA 98225
pp.116-117 *Victorian Roses* © Mary Gregg Byrne

NANCY CONDIT
Sand Dollar Gallery
1256 S. Pearl St.
Denver, CO 80210
p.22 *Morning Tea* © Nancy Condit

MARI M. CONNEEN, NWS
441 N. Harbor City Blvd., C-14
Melbourne, FL 32935
(407) 259-1492
Fax: (407) 259-1494
p.128 *Catch Me if You Can* © Mari M. Conneen

JOHN COX
Legacy Galleries
7178 E. Main St.
Scottsdale, AZ 85251
pp.2-3, p.38 *Cactus Color* © John Cox, Legacy Fine Art, Scottsdale, AZ

LINDY DALY
4318 Gibson St.
Houston, TX 77007-8052
(713) 862-8052
p.27 *Sunflower Landscape* © Lindy Daly

SANDY DELEHANTY
P.O. Box 130
Penryn, CA 95663
(916) 652-4624
p.33 *Springtime Celebration* © Sandy Delehanty, limited edition prints available

MISSIE DICKENS
1205 Sunset Drive
Greensboro, NC 27408
p.105 *Hibiscus Quilt* © Missie Dickens, collection of Dr. and Mrs. Thomas Castelloe, Raleigh, NC

LINDA KOOLURIS DOBBS
330 Spadina Rd., Suite 1005
Toronto, Ontario
Canada M5R 2V9
p.118 *Lampost and Bougainvillaea* © Linda Kooluris Dobbs

VIE DUNN-HARR
327 Pool
San Antonio, TX 78223
(210) 532-8036
p.95 *Blue Irises* © Vie Dunn-Harr
p.137 *Renaissance Iris* © Vie Dunn-Harr

BARBARA EDIDIN
10401 N. 22nd Pl.
Phoenix, AZ 85028
p.23 *Sweet William* © Barbara Edidin
pp.70-71 *An Embarrassment of Roses* © Barbara Edidin

MARLA EDMISTON
Edmiston Fine Art & Prints
2698 Helena Flats Rd.
Kalispell, MT 59901
(406) 257-6060
Fax: (406) 756-6855
p.26 *The Watering Can* © Marla Edmiston
p.92 *Sunday Brunch* © Marla Edmiston

CAITLIN E. FLYNN
P.O. Box 2396
Sedona, AZ 86339
p.136 *Celebration* © Caitlin E. Flynn

PAT FORD
11138 W. Bayshore Dr.
Traverse City, MI 49684
(616) 947-8714
p.74 *Symphony* © Pat Ford

MARY K. FORSHAGEN
2 Duchess Ct.
Houston, TX 77024
p.28 *Texas Gold* © Mary K. Forshagen, courtesy of Whistle Pik Galleries, Fredericksburg, TX
p.100 *Tahoe Still Life* © Mary K. Forshagen, collection of Ann Ingraham Reed

LISA FIELDS FRICKER
Fricker Studio, Inc.
8865 North Mount Dr.
Alpharetta, CA 30022
(770) 642-2148
p.59 *Among the Iris* © Lisa Fields Fricker, collection of Randy and Kelly Schrimsher
pp.110-111 *The Old Shed* © Lisa Fields Fricker

MICHAEL GERRY
c/o Studio Publishing, Inc.
360 Historical Ln.
Long Grove, IL 60047
(800) 607-8834
p.52 *Roses With Dew* © Michael Gerry
p.98 *Apple Blossoms* © Michael Gerry

JANIE GILDOW
905 Copperfield Ln.
Tipp City, OH 45371
E-mail: jagildow@erinet.com
p.129 *Broken Promise* © Janie Gildow

DOUG GORRELL
Doug Gorrell Studio
1800 South Taylor
Little Rock, AR 72204
E-mail: gorrell@alltel.net
(501) 664-8074
p.127 *Fleurs d'étré à St. Etienne* © Doug Gorrell, photo by George Chambers

LOIS GRIFFEL
The Cape Cod School of Art
48 Pearl St.
Provincetown, MA 02657
p.14 *Summer Lilies* © Lois Griffel
p.29 *Dramatic Light* © Lois Griffel, courtesy of Christopher Gallery, Cohasset

ELIZABETH GROVES
2430 Alamo Glen Dr.
Alamo, CA 94507
p.20 *Veronique's Garden* © Elizabeth Groves

ALBERT HANDELL
P.O. Box 9070
Santa Fe, NM 87501
(505) 983-8373
Fax: (505) 989-3863
p.79 *Summer's Kaleidoscope* © Albert Handell, collection of Harry and Renata Berry

KAREN HONAKER
3304 Marcel Ct.
San Jose, CA 95135
p.132 *Sundance* © Karen Honaker, collection of Dr. and Mrs. Tom Glaser

DOROTHY HRABACK
501 South Cornell
Villa Park, IL 60181
p.61 *Hinsdale Summer* © Dorothy Hraback, collection of Patricia Coombs

RACHEL CRAWFORD IMLAH
199 Markham St.
Middletown, CT 06457
(860) 347-7464
p.85 *Red Parrot Tulips* © Rachel Crawford Imlah, collection of The Sensual Garden

BILL JAMES, PSA-M, KA, AWS, NWS
15840 S.W. 79th Ct.
Miami, FL 33157
(305) 238-5709
p.101 *Flowers—Long Shadow* © Bill James

ROBERT A. JOHNSON
217 Walnut Ln.
Vienna, VA 22180
(703) 938-5172
Fax: (703) 255-3160
p.121 *Peonies in an Asian Vase* © Robert A. Johnson, courtesy of the Meyer Gallery, Scottsdale, AZ

JANE JONES
9141 W. 75th Pl.
Arvada, CO 80005
p.42 *Antherium* © Jane Jones

YEE WAH JUNG, NWS, WHS
5468 Bloch St.
San Diego, CA 92122
p.68 *For a Refreshing Combination* © Yee Wah Jung

CAROLE KATCHEN
624 Prospect Ave.
Hot Springs, AR 71901
p.30 *Summer in the South* © Carole Katchen, courtesy of Telluride Gallery, Telluride, CO
p.78 *Memories of Love* © Carole Katchen, collection of Kevin McKiever

MARY KAY KRELL
4001 Ashley Ct.
Colleyville, TX 76034
p.56 *Orchid Song* © Mary Kay Krell, collection of Robert and Mary Marsh

ROBERT J. KUESTER
Kuester/Schwark Painting Workshops
612 Oreja De Oro
Rio Rancho, NM 87124
pp.12-13 *A Rose is a Rose* © Robert J. Kuester
p.21 *Still Life With Homemade Fruit Basket* © Robert J. Kuester

MELANIE S. LACKI
7962 Kentwood Way
Pleasanton, CA 94588
p.31 *Purple Phazes* © Melanie S. Lacki

HEIDI J. KLIPPERT LINDBERG
HCI Box 89
Eastsound, WA 98245
E-mail: lindberg@thesanjuans.com
(360) 376-4528
Fax: (360) 376-3109
p.46 *Sunset* © Heidi J. Kilppert Kindberg

KEVIN D. MACPHERSON
12 Clint Rd.
Taos, NM 87571
p.66 *Casa Blancas and Red Sunflowers* © Kevin D. MacPherson
p.93 *Tulips and Tom* © Kevin D. MacPherson
p.115 *Turquoise Mexican Pitcher* © Kevin D. MacPherson

WENDY MATTSON
P.O. Box 1063
Placerville, CA 95667
p.131 *Unfettered* © Wendy Mattson

JOAN MCKASSON
7976 Lake Cayuga Dr.
San Diego, CA 92119
p.37 *Sunflowers in the Garden* © Joan McKasson

SUSAN MCKINNON, NWS
2225 S.W. Winchester Ave.
Portland, OR 97225
p.102 *Iridescence II* © Susan McKinnon, collection of Rose Foster

OLGA J. MINICLIER
1880 Bellaire St.
Denver, CO 80220
(303) 333-5302
pp.64-65 *Bavarian Spring* © Olga J. Miniclier

J. CHRIS MOREL
HC 65, Rt. Box 26B
Vadito, NM 87579
(505) 587-0359
p.55 *Afternoon Flowers* © J. Chris Morel

DOUGLAS P. MORGAN
331 Cherry St.
San Francisco, CA 94118
(415) 387-8426
p.54 *The Weiss Garden* © Douglas P. Morgan

JUDY MORRIS, NWS
2404 E. Main St.
Medford, OR 97504
E-mail: jmorrisnws@aol.com
p.120 *The Entry* © Judy Morris

ELIZABETH MOWRY
c/o Woodstock School of Art
Rt. 212, Box 338
Woodstock, NY 12498
p.57 *Josie's Poppies* © Elizabeth Mowry
p.81 *Hurley Sunflowers* © Elizabeth Mowry

CHARLES WARREN MUNDY
Charles Warren Mundy Studio/Gallery
8609 Manderley Dr.
Indianapolis, IN 46240
(317) 848-1330
p.18 *Garden at Sissinghurst* © Charles Warren
Mundy, private collection
p.49 *White Lilies* © Charles Warren Mundy,
private collection

BARBARA NEWTON
17006 106th Ave. S.E.
Renton, WA 98055
Web site: www.halcyon.com/bina
p.58 *Peonies* © Barbara Newton

LORETTA NORTH
5521 Grassy Run Ct.
Placerville, CA 95667
p.90 *The Oak Barrel* © Loretta North,
collection of Barbara and Nick Jensen

ANNE MARIE OBORN
987 Millstream Way
Bountiful, UT 84010
(801) 298-5694
p.34 *Ornamental Cherry Blossoms* © Anne
Marie Oborn
p.48 *Purple Allium* © Anne Marie Oborn,
collection of Paul and Gayle
Neuenschwander

BONNIE PARUCH
2007 Park Ave.
West Bend, WI 53090
(414) 335-2176
p.60 *Sweet Gentle Light* © Bonnie Paruch,
collection of Susan Mauney, Southport, NC

ANN PEMBER
Water Edge Studio
14 Water Edge Rd.
Keeseville, NY 12944
pp.96-97 *Handsome Hollyhock* © Ann Pember

JOYCE PIKE
2536 Bay Vista Ln.
Los Osos, CA 93402
(805) 528-3331
Fax: (805) 528-1251
p.91 *The Oriental Plantstand* © Joyce Pike,
courtesy of Gallery Americana, Carmel By
The Sea, CA

CAROLYN RAISIG
12346 N.E. 26th Pl.
Bellevue, WA 98005
(425) 881-2828
p.84 *Cattleya Orchid* © Carolyn Raisig

DIANA REINEKE
Plein Air Painter
7041 Woodman Ave., #2
Van Nuys, CA 91405
(818) 994-7984
p.39 *Poetry of the Poppies* © Diana Reineke,
collection of the Poulsen Gallery,
Pasadena, CA

RODOLFO RIVADEMAR
1866 Maine Ave.
Long Beach, CA 90806
p.107 *Floral Portrait* © Rodolfo Rivademar

MICHAEL P. ROCCO, AWS
2026 S. Newkirk St.
Philadelphia, PA 19145
p.133 *On Capri* © Michael P. Rocco

JUNKO ONO ROTHWELL
3625 Woodstream Cir.
Atlanta, GA 30319
p.87 *Field of Wildflowers I* © Junko Ono
Rothwell
p.134 *Field of Wildflowers II* © Junko Ono
Rothwell

SANDRA SALLIN
c/o Koplin Gallery
464 N. Robertson Blvd.
Los Angeles, CA 90048
p.47 *Illuminant* © Sandra Sallin, courtesy of
the Koplin Gallery
p.109 *White Shadows* © Sandra Sallin,
collection of the Beverly Hills Hotel

ALEXANDER D. SELYTIN
3295 N. 350 East St.
Provo, UT 84604
(801) 377-2221
p.86 *Pansy Potpourri* © Alexander D. Selytin
p.125 *Keepsakes* © Alexander D. Selytin

BARBARA SIMMONS, SCA, CSPWC
74 Lucerne Ave.
Pointe Claire, Quebec
Canada H9R 2V2
p.112 *Irises* © Barbara Simmons, private
collection

PENNY SOTO
2586 Shadow Mountain Dr.
San Ramon, CA 94583
(510) 820-0708
p.130 *Lost Loves* © Penny Soto

SUSANNA SPANN
1729 8th Ave. W.
Bradenton, FL 34205
pp.76-77 *Guards at the Gate* © Susanna Spann
pp.122-123 *Mother Nature's Lace* © Susanna
Spann, collection of Theresa and William
Murphy

JEAN UHL SPICER
11 Tenby Rd.
Havertown, PA 19083
p.94 *Familiar Friends* © Jean Uhl Spicer

SHIRLEY STALLINGS
Mukilteo, WA 98275
(425) 513-2497
p.108 *Dahlia* © Shirley Stallings

JAMES M. SULKOWSKI
329 Hawthorne St.
Canonsburg, PA 15317
(724) 746-1573
p.17 *Floral With Antique Urn* © James M.
Sulkowski

JEANNINE M. SWARTZ
407 N. Market St.
Mechanicsburg, PA 17055
(717) 697-0407
p.75 *Peonies in Crystal* © Jeannine M. Swartz

VIVIAN R. THIERFELDER
P.O. Box 3568
Spruce Grove, Alberta
Canada T7X 3A8
p.32 *Boogie* © Vivian R. Thierfelder
p.53 *Flor Temprano* © Vivian R. Thierfelder

SHARON TOWLE
2417 John St.
Manhattan Beach, CA 90266
pp.50-51 *Crystal Reflections With Roses*
© Sharon Towle
p.114 *Poppy Opulence* © Sharon Towle

JUDY D. TREMAN
1981 Russell Creek Rd.
Walla Walla, WA 99362-9347
pp.24-25 *Heralds to Spring* © Judy D. Treman

KATHLEEN WATKINS
12427 N. 66th St.
Scottsdale, AZ 85254
p.89 *Santa Fe Poppies* © Kathleen Watkins

CHRIS KEYLOCK WILLIAMS, NWS
6213 S.E. Main
Portland, OR 97215
p.16 *Bow Ties* © Chris Keylock Williams,
private collection

ALAN WOLTON, OPA, SAI
25 Last Wagon Circle
Sedona, AZ 86336
(520) 282-4250
Fax: (520) 282-0761
p.135 *Spring in the Air* © Alan Wolton

GARY H. WONG
1410 Abajo Dr.
Monterey Park, CA 91754
p.63 *California Spring* © Gary Wong
pp.82-83 *Lavender in Bloom* © Gary Wong

M. LAUBHAN YANKE
HCR 3, Box 27
Sunray, TX 79086
pp.10-11 *Garden Walk* © M. Laubhan Yanke,
private collection
p.62 *August* © M. Laubhan Yanke, private
collection
p.67 *Hold This Moment* © M. Laubhan Yanke,
private collection

ZHANG WEN XIN
12408 Monarch N.E.
Alberquerqe, NM 87123
p.1 *Rose* © Zhang Wen Xin, private collection
p.126 *Freesia* © Zhang Wen Xin

ROSE ZIVOT, PSA, PPC, SFCA, ASA
53 Medford Pl. S.W.
Calgary, Alberta
Canada T2V 2G1
p.106 *Paeony Tulips* © Rose Zivot